Twilight of Arcadia

American Landscape Painters in Rome, 1830–1880

Twilight of Arcadia

American Landscape Painters in Rome, 1830–1880

John W. Coffey

Bowdoin College Museum of Art · Brunswick, Maine · 1987

This catalogue accompanies an exhibition
of the same name at the Bowdoin College Museum of Art
from April 3 to July 5, 1987.

Cover: Detail, George Loring Brown,
Sunset, View of Vesuvius and the Bay of Naples, 1864,
Bowdoin College Museum of Art, cat. no. 4.

Designed by Stephen Harvard
Printed and bound by Meriden-Stinehour Press,
Meriden, Connecticut, and Lunenburg, Vermont

ISBN: 0–916606–14–7
Library of Congress Catalog Number: 87–70111

Contents

Foreword

In *Twilight of Arcadia*, Curator John Coffey interprets the brooding place of Rome in nineteenth-century American landscape painting with sensitivity and sympathy. In so doing, he casts light on Rome at Bowdoin and explains the city's powerful influence on this campus.

Reminders of Rome and of the nineteenth-century passion for Rome are everywhere at Bowdoin College, but especially at the Museum of Art. Among James Bowdoin III's early gifts of art to the College in 1811 were a group of Italian drawings, many of them from seventeenth-century Rome, which John Smibert probably bought there about 1720. While Smibert was in Rome he also acquired (possibly by painting them himself) copies after Raphael and Poussin, which James Bowdoin also gave to the College. The museum's ancient collections contain great works of Roman origin. Charles Follen McKim's 1892 design for the Walker Art Building speaks of a specific Roman place, the Villa Medici, of antiquity and its revival. And Elihu Vedder's painting *Rome*, commissioned as part of the original decoration for the building, has the most prominent position among the four murals in the rotunda.

The two most famous alumni of Bowdoin College, both writers and graduates of the class of 1825, traveled to Rome during the period of the *Twilight of Arcadia*. Henry Wadsworth Longfellow lingered there on his trip through Italy, learning the language well enough to become, on his return, Bowdoin's first teacher of Italian. Nathaniel Hawthorne's *Marble Faun* is one of the best portraits of the artist's world in Rome of the period.

My special thanks go to the lenders to the exhibition. Without their generous cooperation, *Twilight of Arcadia* would not have been possible. The endorsement and support of the administration and Governing Boards have also been essential; in particular, I wish to express my indebtedness to President A. LeRoy Greason and Dean of the Faculty Alfred H. Fuchs.

My greatest gratitude is to John Coffey, for his vision of the project and for his determination in completing it. His graceful essay probes and clarifies; the works he selected give us Arcadia in mud season.

Katharine J. Watson
DIRECTOR
APRIL 1987

Acknowledgments

An exhibition of this scope is a collaborative effort for which many people deserve credit. *Twilight of Arcadia* has been contributed to by so many that, were the laurels distributed equally, each of us would receive only a single leaf.

Director Katharine J. Watson and the staff of the Museum of Art have contributed to this project from its conception through every aspect of its development and presentation. One could not hope for better colleagues—or stronger friends.

The generous cooperation of the lenders, both public and private, is deeply appreciated. Special mention should be given to the staffs of the lending institutions: Christine Miles and Christine T. Robinson, Albany Institute of History and Art; Linda S. Ferber, Annette Blaugrund, Barbara Dayer Gallati, and Barbara LaSalle, The Brooklyn Museum; Robert M. Doty and Marilyn Hoffman, The Currier Gallery of Art; Jacquelynn Baas and Rebecca A. Buck, Hood Museum of Art; Edgar Mayhew and Leonora Karterud, Lyman Allyn Museum; Frank Trapp and Judith A. Barter, Mead Art Museum; John K. Howat, Natalie Spassky, and Marceline McKee, The Metropolitan Museum of Art; Theodore E. Stebbins, Jr., Trevor Fairbrother, and Linda Thomas, Museum of Fine Arts, Boston; Daniel C. DuBois and Janice LaMotta, The New Britain Museum of American Art; Ella M. Foshay, Christine I. Oaklander, and Mary Alice Mackay, The New-York Historical Society; Mrs. John C. Newington and Florence Levins, The Newington-Cropsey Foundation; James A. Welu, Susan E. Strickler, and Sally R. Freitag, Worcester Art Museum; and Mary G. Neill, Helen A. Cooper, and Rosalie Reed, Yale University Art Gallery. In addition, valuable assistance with loans has been provided by Ben Rifkin and Anne Young, Rifkin-Young Fine Arts, Inc.; and James Berry Hill, Berry-Hill Galleries, Inc.

Research for the catalogue was greatly aided by the staffs of the Archives of American Art, Boston and New York branches; the Bowdoin College Library; the New York Public Library; and the library of the Sterling and Francine Clark Art Institute.

Among the many friends and colleagues who shared their expertise and enthusiasm are Linda J. Docherty, Charles C. Eldredge, Elizabeth Milroy, Gwendolyn L. Owens, and Arlene Palmer Schwind.

The catalogue profitted from the editorial discipline of Susan L. Ransom and was shepherded through publication by Lucie G. Teegarden and Rachel D. Dutch of the College's Office of Public Relations and Publications. Stephen Harvard provided the design.

And special thanks to Ann Roth.

John W. Coffey
CURATOR

Lenders to the Exhibition

Albany Institute of History and Art, Albany, New York

The Brooklyn Museum, Brooklyn, New York

Denison Burton, Chatham, New Jersey

Dr. Henry A. Camperlengo, Albany, New York

The Currier Gallery of Art, Manchester, New Hampshire

Henry Melville Fuller, New York

Hood Museum of Art, Dartmouth College, Hanover, New Hampshire

Mr. and Mrs. Maurice N. Katz, Naples, Florida

Lyman Allyn Museum, New London, Connecticut

Mead Art Museum, Amherst College, Amherst, Massachusetts

The Metropolitan Museum of Art, New York

Museum of Fine Arts, Boston, Massachusetts

The New Britain Museum of American Art, New Britain, Connecticut

The Newington-Cropsey Foundation, Greenwich, Connecticut

The New-York Historical Society, New York

Private Collection. Courtesy of Berry-Hill Galleries, New York

D. Wigmore Fine Art, Inc., New York

Worcester Art Museum, Worcester, Massachusetts

Yale University Art Gallery, New Haven, Connecticut

The Twilight of Arcadia

The idea for this exhibition was prompted by the recent cleaning—and transformation—of two important Mediterranean views by George Loring Brown (catalogue no. 4) and John Rollin Tilton (cat. no. 24).[1] Both artists lived long years in Rome and enjoyed international celebrity during their lifetimes,[2] but by the first decade of this century, when these paintings entered the museum's collection, their names had lost all currency. A similar fate befell many of the American landscape painters in Italy. Their pictures, no longer fashionable, were quietly removed from gallery walls and consigned to the oblivion of the storeroom. It was therefore easy for historians of American art to overlook the real achievements of these painters.

Until the nineteenth century, landscape painting was judged a minor art.[3] The natural world was thought raw and fundamentally incomprehensible and therefore unsuitable as a medium for ideas. Its purpose in art was largely decorative or, like the storm above Golgotha, supplementary to the main subject. In the hands of a Poussin or a Claude, landscape painting could aspire to the refined lyricism of poetry. But its lyrics were never epic. By long-accepted convention, artists visualized the great themes of life in the expression of the human figure. Nature, if treated at all, was accessory.

The first important American-born painters to visit Italy and Rome subscribed to this view. Benjamin West in 1761 and John Singleton Copley in 1775 followed the way well traveled by artists who, since the Empire, had regarded a sojourn in Rome as an essential experience.[4] Though they diligently studied the antiquities and the old masters, West and Copley gave little attention to Italian scenery. As painters of portraits and events they valued landscape only as a theatrical backdrop: the Colosseum appears in the distance of Copley's *Portrait of Mr. and Mrs. Ralph Izard* (1775),[5] but serves only to denote the antiquarian interests of the sitters.[6]

In 1804 Washington Allston arrived in Italy for what became a four-year tour, including an extended residence in Rome.[7] Though primarily a painter of historical and religious themes, Allston appreciated the poetics of landscape painting. He carefully studied the glazed color of the Venetian masters and the finely tuned harmonies in the luminous vistas of Poussin and Claude. If his landscape compositions seem rote recitations of lessons learned in the picture galleries, they were still the first significant landscapes by an American artist. Widely exhibited, they awakened a younger generation of painters to the classical eloquence of nature and, not incidentally, to the lure of Italy.

The shuttered view of the natural world gave way during the last half of the eighteenth century to a more expansive vision, of which Allston's work was an early indication. Scientific and philosophical inquiry revealed nature as systematic, possessing order and mechanism which the enlightened Christian understood to be divinely wrought. And as the manifestation of God's presence, the natural world was held to be perfect and morally superior to the human. This was a central conviction of the romantics, who sought in the contemplation of nature a privileged, spiritual truth. As a direct consequence, landscape painting acquired the authority of devotional art.

The cult of nature found zealous disciples in the New World, where the wilderness, once so menacing, was now revered as a sanctuary. Thomas Cole, the guiding spirit among the painters of the Hudson River school and their most eloquent voice, asserted that:

> those scenes of solitude from which the hand of nature has never been lifted, affect the mind with a more deep toned emotion than aught which the hand of man has touched. Amid them the consequent associations are of God the creator—they are his undefiled works, and the mind is cast into the contemplation of eternal things.[8]

It was the utter sanctity of the American landscape that the Hudson River school celebrated. As they imagined it, the New World was sunrise and Eden.

As enthusiastic as he was about wilderness, Cole did go on to confess that "simple nature is not quite sufficient. We want human interest, incident and action, to render the effect of landscape complete."[9] Ambitious to depict the whole of human destiny in his

art, Cole found the New World a poor theater for his pageant. America lacked a visible heritage, the suggestive marks and scars of a long history. One read the wilderness as a *tabula rasa*. The Catskills, however splendid, had not the intellectual interest of an ancient and storied land. This idea was repeatedly if reluctantly conceded by Cole's contemporaries. In his essay "American and European Scenery Compared," James Fenimore Cooper allowed "to Europe much the noblest scenery . . . in all those effects which depend on time and associations."[10] Since, for Cole, it was those historical associations that most engaged his imagination, their scarcity at home led him abroad and to Italy.

Henry Tuckerman, the contemporary biographer and critic of American artists, noted with unconcealed pride that an American artist more than any other would be affected by a visit to Italy:

> The contrast between the new and old civilization, the diversity in modes of life, and especially the more kindling associations which the enchantment of distance and long anticipation occasion, make his sojourn there an episode of life.[11]

Tuckerman saw little harm and much gain for an American artist abroad. Others saw just the opposite. Writing in 1847 from Rome, Margaret Fuller frankly observed that "although we have an independent political existence, our position towards Europe as to literature and the arts is still that of a colony."[12] Few would have disagreed with her though the idea angered many advocates of *American* art. Protesting that entirely too much deference was paid the Old World by the New, the painter Asher B. Durand asked "why should not the American landscape painter, in accordance with the principle of self government, boldly originate a high and independent style, based on his native resources?" He further urged aspiring painters to "go not abroad . . . while the virgin charms of our native land have claims on your deepest affections."[13] What most concerned Durand was the effect of foreign study upon the young artist. He feared that exposure to Europe's proud academics and masterpieces would only corrupt American originality.[14] But even Durand enjoyed a profitable year abroad.

Italy, even the illusion of Italy, was a potent narcotic for American artists. One senses its hallucinatory effects in the numerous Italianate landscapes painted before the artists had yet ventured abroad.[15] For Rembrandt Peale, as for many others, Italy was that special object of desire, "my reverie by day [and] the torment of my dreams at night."[16] Artists longed for it as though it were Canaan. John Neal recalled when the young Tilton "began to talk . . . of seeing Italian shores and breathing Italian atmosphere. It was a wild, strange dream, . . . vast and gorgeous and shadowy."[17] The dream was realized by Tilton and a troupe of painters and sculptors during the middle decades of the nineteenth century. And for most of them the supreme goal, the consummation of the dream, was Rome.

Rome was a training ground for artists of the Hudson River school. Between 1830 and 1880 virtually every major American landscape painter made the pilgrimage. Most came for a season or a year as part of a wider European tour, but some stayed for many years, joining a large international colony of artists and writers. Challenged by the pantheon of old masters, they acquired greater proficiency, even sophistication, in the craft of painting. The serene and sun-washed landscapes of Italy tested their perceptions of nature. And the awesome presence of antiquity inspired and troubled their imaginations.

Most of the American artists came to Rome as young men, exuberant, even giddy. For them, Rome had no reality other than art. Like the tourist whose perceptions were lifted from guidebooks and Byron, the American painter envisioned Italy through the dreamy eyes of Claude and Turner. He had studied the landscapes of these and other masters in the galleries of London and Paris. He had made copies, so many and so well that George Loring Brown was nicknamed "Claude."[18] By the time he reached Rome, the American had acquired fluency in the classical language of landscape. As courtly and artificial as this language was, it provided a ready means for the artist to comprehend Rome's mythic dimension, what Henry James called "the sovereign spirit of the place."[19]

Arriving in Rome, American artists were welcomed into a large and thriving international colony dating back to the Empire and settled in the northern extremity of the city between the Piazza di Spagna and the Porta del Popolo. *Murray's Handbook,* the Victorian's *Blue Guide,* observed rather grandly that "the artists of all nations resident in Rome may be said to form one fraternity; and it is an honourable circumstance that men speaking so many different languages meet at Rome upon common ground, as if there were no distinction of country among those whom Art has associated in her pursuit."[20] Generally speaking, it was a supportive community—far

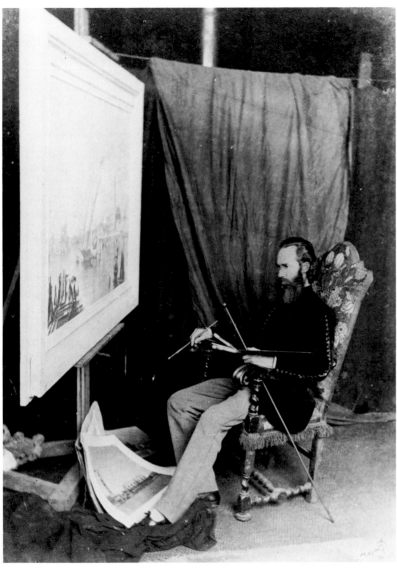

John Rollin Tilton in His Studio, Rome, 1865, John Neal Tilton Papers, Archives of American Art, Smithsonian Institution

more supportive than any found in America. Nathaniel Hawthorne noted in *The Marble Faun* that artists in Rome "find themselves in force, and are numerous enough to create a congenial atmosphere. In every other clime, they are isolated strangers; in this Land of Art, they are free citizens."[21] And free of home, they affected a colorful and well-studied bohemianism that served to insulate as well as to set them apart from the rest of the population. Like any fraternity, they had their quaint customs. Mornings and evenings they gathered in the smoky rooms of the Caffè Greco to argue art or business or confide the latest gossip.[22] In the spring they celebrated the *Festa di Artisti*, a day of high revelry, of mock processions, banquets, and wildly satiric theatricals.[23]

Artists were part of the sites and scenery of Rome. The painter Thomas Appleton commented in 1834 that "one can not take a walk without seeing some fellow seated on a ruined column, with his colors beside him, sketching some temple or group, unmolested and abstracted."[24] Tourists were fascinated, and the guidebooks were quick to supply the addresses of the artists' studios. *Murray's* notes that "among those characteristics of Modern Rome which are capable of affording the highest interest to the intellectual traveller, we know of none which possess a greater charm than the studios of the artists."[25] A saunter through the studios, like a moonlight visit to the Colosseum, became one of the duties of a conscientious tourist in Rome.

With the Church no longer a major patron, artists catered more and more to the tourist trade. Not surprisingly, the American's best customer was his fellow countryman. William Cullen Bryant remarked upon the irony of "the rich man who, at home, is contented with mirrors and rosewood, is here initiated into a new set of ideas, gets a taste, and orders a bust, a little statue of Eve, a Ruth, or a Rebecca, and a half dozen pictures, for his luxurious rooms in the United States."[26] Of course, the artists' dependence upon tourist capital left them especially sensitive to the political unease of Italy and the economic fluctuations at home. The relative calm and prosperity of the early 1850s contributed to the marked rise in the number of Americans abroad and a comparable increase in the number of American artists resident in Rome. In 1858 Bryant estimated the number at "thirty or more."[27] However, the prolonged depression loosed by the Panic of 1857 and followed shortly by the outbreak of the American Civil War reversed the tides of tourists and

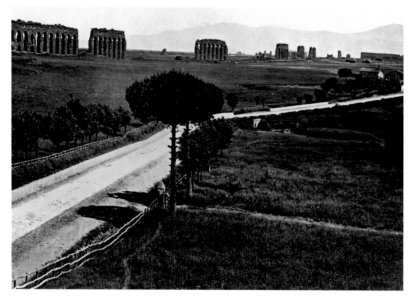

Giorgio Sommer, *Claudian Aqueduct, Roman Campagna*, ca. 1880
Bowdoin College Museum of Art

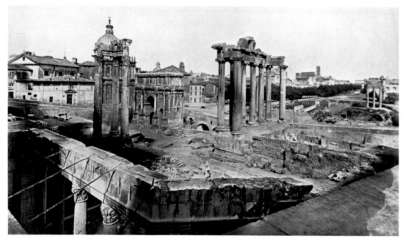

Robert Macpherson, *View of the Roman Forum*, ca. 1865
Bowdoin College Museum of Art

"those who have succeeded in coming abroad do not seem inclined to invest much money in the fine arts."[28] With prospects bleak, many American artists returned home.

The expatriate community in Rome was transient and ephemeral. "People come and go like shadows," complained the sculptor Thomas Crawford, "making room for others who will follow us in the same manner."[29] Only a few American artists took up permanent residence.[30] The rest lingered for a while and then continued on their European tours. The artists were most in evidence during the autumn and winter season, when the Roman sun was mildest and the city swarmed with visitors.

With the end of Holy Week and the onset of the dust-dry sirocco, Rome quickly emptied of tourists. The artists, too, quit the city for cooler climes. Some trekked north to Switzerland and Germany while others remained in Italy, sketching among the lakes and hill towns. In *Roderick Hudson*, Henry James describes the summer idyll of one "honest little painter [who] rambled about among the unvisited villages of the Apennines, pencil in hand and knapsack on back, sleeping on straw and eating black-bread and beans, but feasting on local color, rioting, as it were, on chiaroscuro, laying up treasures of pictorial observations."[31] These observations, recorded in portfolios of drawings and oil sketches, constituted the raw material from which the artists synthesized their more polished studio compositions.

For the American beguiled by arcadian dreamscapes, the actuality of modern Rome often proved a rude awakening. Until 1870 Rome was not only the center of world Catholicism, but also the capital of a miscellany of Central Italian territories over which the Pope ruled as prince. A curious vestige of the *ancien régime*, the Papal States had long drifted in the backwaters of European politics. It was less a nation than a facsimile, having only the appearance and not the coherence of statehood.

The city of Rome expressed the declining fortunes of the papacy. It was the least modern of great capitals. In plan and aspect it was still a medieval town, veneered with the crumbling splendor of the Renaissance and Baroque past. Its population of 180,000 was compressed into warrens of streets and alleys covering only a third of the imperial city.[32] Vast tracts within the circuit of the Aurelian Wall were abandoned to pasture.

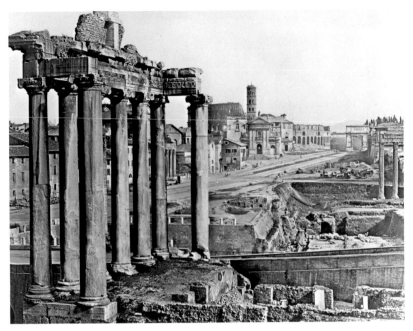

James Anderson, *View of the Roman Forum Facing the Colosseum*, ca. 1870
Private Collection, Courtesy of Jill Quasha

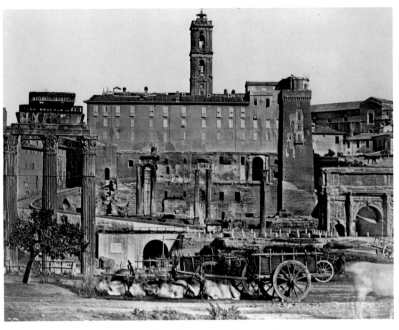

James Anderson, *View of the Roman Forum Facing the Capitol*, ca. 1865
Bowdoin College Museum of Art

Papal Rome was a city formed and reformed out of its own ruin, the stones of its architecture quarried from the temples and monuments of the Caesars. The far past coexisted dramatically with the present, and the future seemed incomprehensible. The weight of accumulated time subdued all thoughts of progress and possibility. "The degeneracy of modern Rome," wrote Tuckerman, "is a subject ever forced upon the thoughtful resident. . . . And to one who is anywise familiar with her past history, or susceptible to her present influences, it becomes an almost absorbing theme."[33] It was a theme that absorbed many pages in the travel journals of Americans. Over and again one reads a litany of complaints and censure. The Reverend Orville Dewey judged the city a "dismal, dirty, disagreeable place."[34] Charles Elliott found it "vile."[35] To these James J. Jarves added, "comfortless, torpid, the home of beggars, indolence and

superstition."[36] In the winter of 1858 Nathaniel Hawthorne jotted down his sour impressions: "Cold, nastiness, evil smells, narrow lanes between tall, ugly, mean-looking, white-washed houses."[37] The fabled Tiber was "like a saturated solution of yellow mud."[38] A reluctant and querulous tourist, Hawthorne never warmed to Rome. Later, in *The Marble Faun*, he refined his aversion, likening it to a "heap of broken rubbish, thrown into the great chasm between our own days and the Empire, merely to fill it up."[39]

Americans abroad affected a hearty Anglo-Saxon bigotry towards the latter-day Romans. They viewed them as a picturesque but degraded race, wholly unworthy of their imperial inheritance. The mobs of beggars appalled them; so too the corrupt and petty-cruel bureaucrats. But it was the clergy who received the greatest portion of Yankee indignation. As righteous Protestants, the Americans had

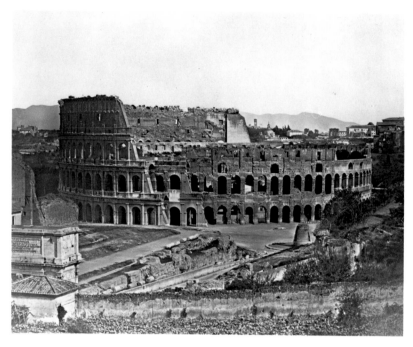

James Anderson, *The Colosseum, Rome*, ca. 1860s
Private Collection, Courtesy of Jill Quasha

little sympathy for the Roman Church. The antique pageantry may have charmed but it was only "gorgeous mummery . . . whose meaning is all of the past, and finds no echo in the future."[40] The church, condemned by Tuckerman as "inimical to human progress and freedom,"[41] was held responsible for the present prostration of Italy. Pondering the state of mid-century Rome, one Indiana tourist wondered "is man here but an insect caught in the unyielding amber of an infallible theocracy?"[42]

There is ample evidence of similar attitudes among the artists in Rome. During his first visit, George Inness defiantly refused to remove his hat in the presence of His Holiness and suffered expulsion from the City.[43] On an earlier occasion Samuel Morse, a virulent anti-Catholic, also declined to doff his cap, only to have it struck off by a "poltroon in a soldier's costume."[44] Such theatrics, however,

were uncommon. In general, the artists kept their feelings private. Mindful of their precarious status as aliens and preoccupied by artistic concerns, they, like James De Veaux, were more than "willing to take the cares of Popedom on my head if it would insure my always living here."[45]

As one might expect, American artists tended to play down the Catholic references in their Italian paintings. This was difficult, since modern Rome was the architectural creation of the papacy. The great basilicas and the pontifical and princely palaces were chiefly ignored. The one important exception was St. Peter's, though its meaning for the artist—and the tourist—was only as a striking and universally recognizable landmark—Rome's Eiffel Tower. When the artists introduced clergy or religious processions in their compositions, the figures were generally minor in scale and significance. Accents of local color, they were stock items in the repertory of every painter of the picturesque. However, given the artists' antipathy to all things Catholic, it is likely that these pious figures were intentionally ironic, emphasizing by their presence in the ruined landscape the final debasement of Rome.[46]

The sad predicament of Rome and Italy had little interest for American painters—at least as it concerned their art. For them, the mean, "unpoetic" present served mainly to darken their already somber meditations on the past.

The romantic held that the past could best be reclaimed by the contemplation of its relics. In the shadow of a fallen arch the mind might conjure an antiquity more vivid and resonant than ever was possible from a reading of Gibbon, or even Byron.[47] And if the journals and memoirs are to be believed, there were few travelers to Rome whose leisurely brooding about the ruins was not repaid by visions. Naturally, some of the most extravagant were played out in the Colosseum, that second-century marvel of Roman engineering and hedonism. Though half-robbed of its stone, it was still the most majestic of ruins and, by its associations with imperial power and ritual slaughter, the most evocative. Standing within its eerie circumference one was easily thrilled:

You suddenly behold the benches as of old thronged with their myriads of human forms—the ghosts of those who once sat there. That terrible circle of eyes is shining at you with a ghastly expression of cruel excitement. You hear the strange, exciting hum of confused voices, and

the roar of wild beasts in the caverns below. You are yourself a gladiator.[48]

Climbing to the crumbling upper tier, Cole looked down and beheld "a vision of the valley and shadow of death."[49] And it was there on a moonlight tryst that Daisy Miller caught her fatal fever.

Surveying the city and environs of Rome, Jarves felt that "the natural atmosphere of both is death, moral and physical."[50] It hovered chill and delicious, like the malarial vapors of the Campagna. No one mistook its presence. Awareness of death—of rapturous communion and oblivion—was essential in the experience of mid-century Rome. In their pictures American artists expressed its twin aspects, painting Italy both as a serene and lyrical Elysium and as a charnel house.

A ready interpretation of the pictures is provided by Cole in *The Course of Empire* (1836), a five-part series of paintings chronicling the history of a nation from tribal savagery through triumphant grandeur to final collapse and oblivion. The idea for the series was outlined by Cole before his visit to Italy in 1832, but it was his Italian experience that prompted him to visualize the epic theme in terms of Roman history and landscape.

Interpreted superficially, *The Course of Empire* is a cautionary tale on the frailty of civilization. It is clear, however, that Cole intended a more intricate meaning. He set his pageant within a splendid imaginary landscape in order to entwine the events of human and natural history. Here, instead of being a backdrop, nature is an active presence, an assertion of the deity in the affairs of men. The primeval wilderness (*The Savage State*) evolves into a bucolic vision of sunlight and emerald (*The Pastoral State*), a moment of classical harmony upset in the next scene (*Consummation of Empire*) by the awesome luxury and license of imperial power. The volcanic storm that overarches the succeeding melodrama of *Destruction* implies the judgment of God—and Cole. And in the concluding scene: "a sunset,—the mountains riven—the city a desolate ruin—columns standing isolated amid the encroaching waters—ruined temples, broken bridges, fountains, sarcophagi, etc.—no human figure."[51] More than tolling "the funeral knell of departed greatness,"[52] the panorama of *Desolation* brings the story full circle. The works of man are resolved into dust, and wilderness reclaims the land.

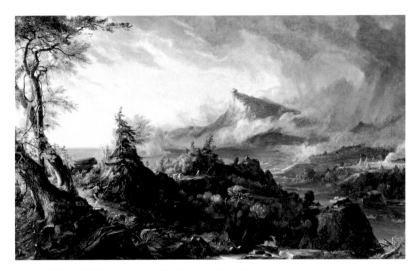

Thomas Cole, *The Course of Empire: The Savage State*, 1836
The New-York Historical Society, New York

For Cole, the catastrophe that befell Rome was not a singular tragedy but only the grandest manifestation of a perpetual cycle of generation, destruction, and regeneration. This cyclic theory of history predates Cole by several generations. A hybrid of Enlightenment and Romantic thought, it identified a rhythmic structure in the course of human events, but the meaning and ultimate purpose of that structure remained inscrutable, the workings of Providence. In its predictability this theory gave both comfort and alarm. It affirmed the existence of God as the composer of history but it also implied the futility of human enterprise. As expressed in *The Course of Empire*, the sublimest achievements of a civilization—law, literature, architecture, even painting—are without enduring value. *Sic transit gloria mundi.*

Though it intones a universal theme, Cole's series had a special resonance for his fellow countrymen. From the first stirrings of the Revolution, Americans had identified closely with Rome—not the decadent Rome of the Popes or Caesars, but the virtuous Rome of Cato and Cicero. The ancient republic had furnished the necessary

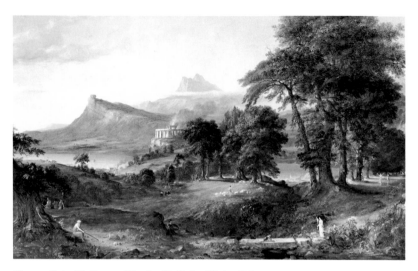

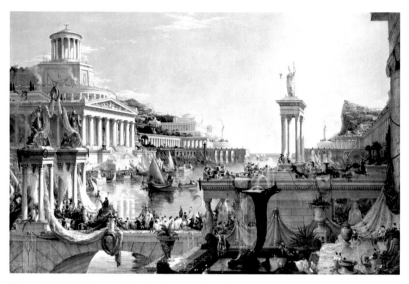

Thomas Cole, *The Course of Empire: The Pastoral State*, 1836
The New-York Historical Society, New York

Thomas Cole, *The Course of Empire: Consummation of Empire*, 1836
The New-York Historical Society, New York

patrimony for the new nation, shaping both the form and character of its civic institutions and lending a tone of moral earnestness to its political life. For Americans, the Roman precedent seemed to guarantee a bright destiny.

Yet the fact was unavoidable that Rome had eventually fallen, and as growing discord strained the unity of the states, Americans came to wonder if they would soon share a similar fate. Alarmed at the nation's decline toward civil war, Cole wrote:

> It is with sorrow that I anticipate the downfall of this republican government; its destruction will be a death blow to Freedom, for if the Free government of the U[nited] States cannot exist a century [,] where shall we turn? The hope of the wise & the good will have perished, and scenes of tyranny & wrong, blood & oppression such as have been acted since the world was created, will be again performed as long as man exists.[53]

The Course of Empire expressed the artist's heartsick pessimism about the future of America. When unveiled, it was immediately and extravagantly praised. Depending upon the quality of his pes-

simism, the viewer read its parable as dire prophecy or stern but timely warning. Either way, he was compelled to reflect upon the probability of national extinction. It is this question that haunts the *Desolation* of Cole's *Empire* and the ruined landscapes of other American artists.

The question for Americans was at least partially resolved by the Civil War. The long-anticipated apocalypse came but left the Union intact and resurgent. As the future again lured their attention and Americans returned to the conquest of their own empire, they all but ceased morbid speculations on declines and falls. They thought themselves the miraculous exceptions to history:

> On firmer ground than the old foundations
> We base the promise of our fate,
> And take the wreck of crumbled nations
> To build an everlasting State.[54]

The war fundamentally altered the Americans' perception of Italy and Rome. Cole's metaphor was now bankrupt. The nation's fate

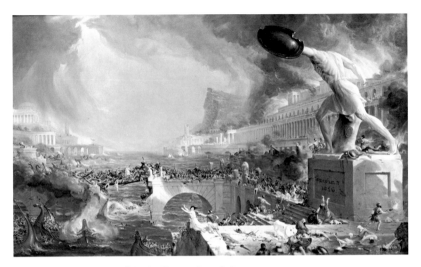

Thomas Cole, *The Course of Empire: Destruction*, 1836
The New-York Historical Society, New York

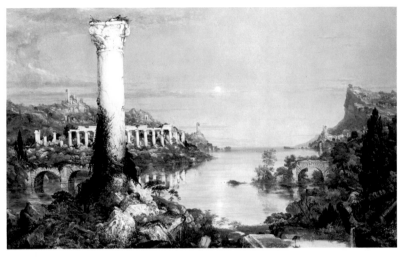

Thomas Cole, *The Course of Empire: Desolation*, 1836
The New-York Historical Society, New York

could not be read in the ruins of antiquity. All that was legible in those stones was a paralyzing confusion without meaning or moral value. The historian Henry Adams, frustrated by the anarchy of impressions, thought Rome "the worst spot on earth to teach nineteenth-century youth what to do with a twentieth-century world."[55]

Though Americans visited Rome in increasing numbers after the war, they expected far less of the experience. For the majority, the ancient past was a simple curiosity. Their questions were few and easily satisfied by the guide book. In his travel journal, the American still might wax rhapsodic over the "mournful relics of Empire," conjuring yet again the phantom gladiators in the Colosseum, but the rhapsodies and the phantoms were only entertainment. They did not personally threaten the visitor as they had those of an earlier generation.

It was not just that Americans had changed; Rome itself had changed. In 1870, the city surrendered to the armies of a united Italy, and Pope Pius IX retreated into the Vatican, ending over a thousand years of papal dominion. As the capital of the new kingdom, Rome was startled out of its time-stilled reverie and forcibly wrested into the present. In short order, the medieval city was transformed into a modern metropolis with all of its vigor and attendant ills. "Old Rome" was recklessly sacrificed to the future. Her American lovers looked on in horror as the "new barbarians" razed the venerable palazzi and gardens for housing and offices and intruded upon the hallowed ground of the Campagna with a sprawl of industrial suburbs.[56] Even the imperial ruins were desecrated by the archaeologist, "the modern representative of the Goth."[57] Cleared and sterilized of the accumulations of time, the monuments lost much of their eloquence.

By 1880, Rome had faded as an art mecca, its brilliance eclipsed by the more cosmopolitan Paris. The city continued to support a sizeable community of artists, although the "joyous fraternity of the brush"[58] was aging. The young American painters took themselves elsewhere for their schooling. For them, Rome was a picturesque irrelevance.

Notes

1 Anyone who ventures after the American artists in Rome must acknowledge the pioneering of Otto Wittman, Jr., Edgar P. Richardson, Van Wyck Brooks, and Regina Soria. The preeminent scholar in the field is Barbara Novak. Her essay "Arcady Revisited," first published in the exhibition catalogue *The Arcadian Landscape: Nineteenth-Century American Painters in Italy* (Lawrence: University of Kansas Museum of Art, 1972), and later expanded in *Nature and Culture* (New York: Oxford University Press, 1980), remains the central work.

2 See Thomas W. Leavitt and William David Barry, *George Loring Brown: Landscapes of Europe and America, 1834–1880* (exh. cat.) (Burlington, Vt.: The Robert Hull Fleming Museum, 1973); and William David Barry and Jean M. Baxter, "John Rollin Tilton," *Antiques* 122 (November 1982): 1068–1073.

3 The best single volume treatment of the development of landscape theory is Kenneth Clark, *Landscape into Art* (Boston: Beacon Press, 1961).

4 See Helmut von Erffa and Allen Staley, *The Paintings of Benjamin West* (New Haven: Yale University Press, 1986); and Jules David Prown, *John Singleton Copley*, 2 vols. (Cambridge, Massachusetts: Harvard University Press, 1966).

5 Collection, Museum of Fine Arts, Boston.

6 Lois Dinnerstein, "The Significance of the Colosseum in the First Century of American Art," *Arts* 58 (June 1984): 116–117, repr. fig. 1.

7 See William H. Gerdts and Theodore E. Stebbins, Jr., *"A Man of Genius": The Art of Washington Allston (1779–1843)* (exh. cat.) (Boston: Museum of Fine Arts, 1979).

8 Thomas Cole, "Essay on American Scenery," *The Collected Essays and Prose Sketches*, ed. Marshall Tymn (St. Paul: John Colet Press, 1980), 8. The essay was first published in 1836.

9 Journal entry, July 17, 1841, quoted in Louis Legrand Noble, *The Life and Works of Thomas Cole*, ed. Elliot S. Vesell (Cambridge, Mass.: Harvard University Press, The Belknap Press, 1964), 219.

10 James Fenimore Cooper, "American and European Scenery Compared," *The Home Book of the Picturesque* (New York: G. P. Putnam, 1852), 69.

11 Henry T. Tuckerman, *Book of the Artists, American Artist Life* (New York: G. P. Putnam & Son, 1867; New York: James F. Carr, 1967), 152.

12 Letter no. 18 to the *New York Tribune*, undated (1847), *The Writings of Margaret Fuller*, ed. Mason Wade (New York: The Viking Press, 1941), 422–423.

13 Asher B. Durand, "Letters on Landscape Painting, II," *The Crayon* 1 (January 17, 1855): 35; ibid., 34.

14 Nathaniel Hawthorne shared Durand's fear that Americans abroad risked their special identity. Of the artists who lingered long in Rome he wrote: "we defer the reality of life . . . until a future moment, when we shall again breathe our native air; but by-and-by, there are no future moments; or, if we do return, we find that the native air has lost its invigorating quality, and that life has shifted its reality to the spot where we deemed ourselves only temporary residents. Thus, between two countries, we have none at all, or only that little space of either, in which we finally lay down our discontented bones." (*The Marble Faun* [New York: The Library of America, 1983], 1237).

15 Jasper Cropsey exhibited an *Italian Composition* at the National Academy of Design in 1843, four years before his first trip abroad (William S. Talbot, *Jasper F. Cropsey, 1823–1900* [exh. cat.] [National Collection of Fine Arts, 1970], 16); Sanford Gifford's first oil was an Italian scene (Ila Weiss, *Sanford Robinson Gifford, 1823–1880* [Ph.D. diss., Columbia University, 1968], 16); and John Neal reported that Tilton, while still in Portland, Maine, made a large copy after Thomas Cole's painting of the Roman aqueducts ("Our Painters—John Rollin Tilton," *The Northern Monthly* 1 (October 1864): 509).

16 Rembrandt Peale, *Notes on Italy* (Philadelphia: Carey & Lea, 1831), 5.

17 Neal, 511.

18 Leavitt, 11. Also, Thomas Cole was frequently hailed by his contemporaries as the "American Claude."

19 Henry James, *William Wetmore Story and His Friends*, vol. 2 (Boston: Houghton Mifflin, 1903), 205.

20 *A Handbook for Travellers in Central Italy, Vol. 2: Rome and its Environs*, 3rd ed. (London: John Murray, 1853), 12.

21 Hawthorne, 962.

22 William Wetmore Story, *Roba di Roma*, vol. 1 (London: Chapman and Hall, 1863), 186.

23 Ibid., 172–177. Also, Florentia, "The Artists' Festa: Rome," *The Art-Journal* (London) 6 (n.s.) (1854): 271–273.

24 Journal entry, February 24, 1834, quoted in *Life and Letters of Thomas Hale Appleton*, ed. Susan Hale (New York: D. Appleton, 1885), 196.

25 *Handbook for Travellers*, 224.

26 William Cullen Bryant, *Letters of a Traveller; or, Notes on Things Seen in Europe and America* (New York: G. P. Putnam, 1850), 260.

27 Letter to the *Evening Post*, May 21, 1858, *The Letters of William Cullen Bryant*, vol. 4, ed. William Cullen Bryant II and Thomas G. Voss (New York: Fordham University Press, 1984), 34. Twenty-four Americans are listed in the 1857 *Artistical Directory; or, Guide to the Studios of the Italian and Foreign Painters and Sculptors Resident in Rome*.

28 E. (pseud.), letter from Rome, *The Crayon* 5 (June 1858): 170. A year later, John Bigelow noted "the fact . . . that the artists at home during the past year have quite generally had orders in abundance, has proved more or less unsettling to the absentees; and I hear of several who have determined to leave Italy at the close of the present season." (Letter from Rome, *The Crayon* 6 [June 1859]: 183).

29 Letter, December 18, 1856, transcript in Archives of American Art, Smithsonian Institution.

30 Remembering his four years in Rome during the 1850s, Worthington Whittredge wrote, "at this time there were but two American landscape painters, Brown and Tilton, who were making Rome a permanent residence. All the others were like swallows that came and went; unlike them only in coming in winter and flying away in summer." (*The Autobiography of Worthington Whittredge*, ed. John I. H. Baur [New York, Arno Press, 1969], 36).

31 Henry James, *Roderick Hudson* (New York: The Library of America, 1983), 260. Longfellow describes a group of artists "vacationing" in the town of Ariccia: "Tired of copying the works of art, they go forth to copy the works of nature; and you will find them perched on their camp-stools at every picturesque point of view, with white umbrellas to shield them from the sun, and paint-boxes upon their knees, sketching with busy hands the smiling features of the landscape." ("The Village of La Riccia," *Outre-Mer*, *The Works of Henry Wadsworth Longfellow*, vol. 7, ed. Samuel Longfellow (Boston: Houghton Mifflin, 1886), 264.

32 Murray's *Handbook* reports the city's population in 1846 as 180,200 (*Handbook for Travellers in Central Italy, Vol. 2: Rome and its Environs*, 3rd ed. [London: John Murray, 1853], 14). The population increased to 201,161 in 1863 (*Handbook*, 7th ed. [1864], xxxvi) and further to 244,484 in 1872 (*Handbook*, 11th ed. [1873], xxxvii).

33 Tuckerman, *The Italian Sketch Book*, rev. ed. (New York: J. C. Riker, 1858), 85.

34 Orville Dewey, *The Old World and the New: or, a Journal of Reflections and Observations Made on a Tour in Europe*, vol. 2 (New York: Harper & Brothers, 1836), 75.

35 Charles W. Elliott, "Life in Great Cities: Rome," *Putnam's Magazine* 1 (n.s.) (February 1868): 219. Elliott summarized his impression of Rome: "All is indifference, mediocrity, stupidity. There is no present, no future(?). Rome is in the Past."

36 James Jackson Jarves, *Italian Sights and Papal Principles, Seen through American Spectacles* (New York: Harper & Brothers, 1856), 351.

37 Journal entry, February 3, 1858, Hawthorne, *The French and Italian Notebooks*, ed. Thomas Woodson, vol. 14 of *The Centenary Edition of the Works of Nathaniel Hawthorne* (Columbus: Ohio State University Press, 1980), 54.

38 Journal entry, February 21, 1858, ibid., 96.

39 Hawthorne, *The Marble Faun*, 944.

40 Margaret Fuller, letter no. 17 to the *New York Tribune*, October 18, 1847, *The Writings of Margaret Fuller*, 416–417.

41 Tuckerman, *The Italian Sketch Book*, 13.

42 Samuel S. Cox, *A Buckeye Abroad* (New York: G. P. Putnam, 1852), 112.

43 Nicolai Cikovsky, Jr., and Michael Quick, *George Inness* (exh. cat.) (Los Angeles: Los Angeles County Museum of Art, 1985), 15.

44 Quoted in *Samuel F. B. Morse: His Letters and Journals*, vol. 1, ed. Edward Lind Morse (Boston: Houghton Mifflin, 1914), 353.

45 Letter, February 12, 1843, quoted in Robert W. Gibbes, *A Memoir of James De Veaux of Charleston, S.C.* (Columbia, S.C.: I. C. Morgan, 1846), 120.

46 The most surprising references to Catholicism are found in Morse's *Chapel of the Virgin at Subiaco* (cat. no. 20) and John Kensett's *The Shrine—A Scene in Italy* (cat. no. 19). In the foreground of each painting a peasant woman kneels before a wayside shrine. One might expect these artists, especially Morse, to dismiss such scenes as idolatrous. But the pictures, despite their titles, are primarily landscapes, devotional only to a radiant and divinely imagined nature. The shrines and figures do not suggest so much the pomp of the Church as the ancient rites of natural religion. As such they lend a simple sanctity to the landscapes.

47 George Hillard, author of one of the most popular travelogues of the mid-nineteenth century, offered a proven recipe for a suggestive ruin: "we build it of such material that every fragment shall have a beauty of its own. We shatter it with such graceful desolation that all the lines shall be picturesque, and every broken outline traced upon the sky shall at once charm and sadden the eye. . . . We set it in a becoming position, relieve it with some appropriate background, and touch it with soft, melancholy light—with the mellow hues of a deepening twilight, or better still, with the moon's idealizing rays." (*Six Months in Italy*, vol. 1 [Boston: Ticknor, Reed and Fields, 1853], 290–291).

48 Story, 218.

49 Notes, May 14, 1832, quoted in Noble, 116. Longfellow, wandering in the moonlit arena, asked himself: "Where were the senators of Rome, her matrons, and her virgins? where the ferocious populace that rent the air with shouts . . . ? Where were the Christian martyrs . . . ? where the barbarian gladiators . . . ? The awful silence answered, 'They are mine!' The dust beneath me answered, 'They are mine!' " ("Rome in Midsummer," *Outre-Mer*, *The Works of Henry Wadsworth Longfellow*, vol. 7, 253).

50 Jarves, 349.

51 Cole to Luman Reed, September 18, 1833, quoted in Noble, 130.

52 Ibid.

53 Journal entry, August 21, 1835, quoted in Cole, *The Collected Essays and Prose Sketches*, 135.

54 Bayard Taylor, "The Voices of Rome," *The Poetical Works of Bayard Taylor* (Boston: Houghton Mifflin, 1883), 203.

55 Henry Adams, *The Education of Henry Adams* (New York: The Library of America, 1983), 802. Adams further wrote that "no one, priest or politician, could honestly read in the ruins of Rome any other certain lesson than that they were evidence of the just judgment of an outraged God against all the doings of man."

56 See William J. Stillman, *The Old Rome and the New, and Other Studies* (Boston: Houghton Mifflin, 1898).

57 Charles Eliot Norton to Meta Gaskell, July 24, 1908, *Letters of Charles Eliot Norton*, vol. 2, ed. Sara Norton and M. A. DeWolfe Howe (Boston: Houghton Mifflin, 1913), 410.

58 Stillman, 13.

Color Plates

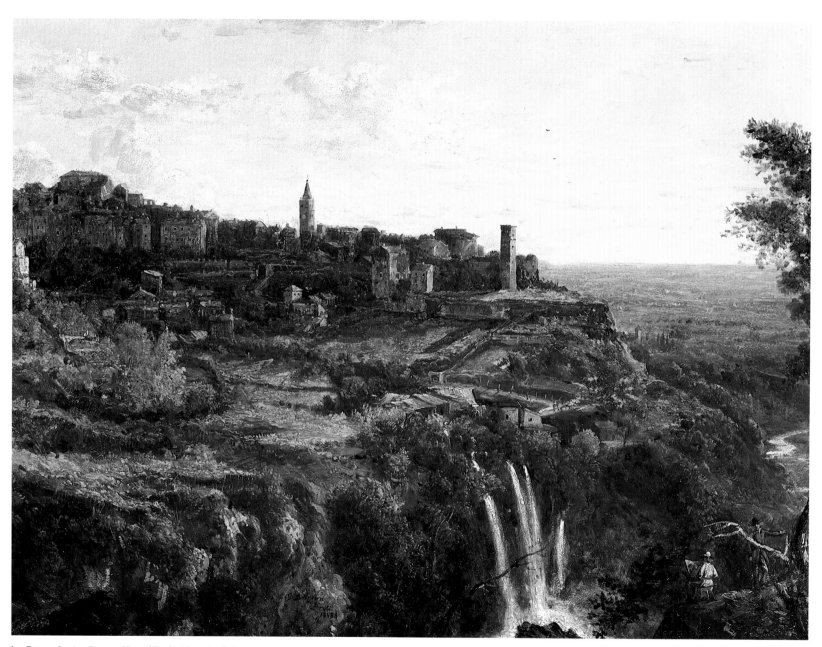

1　George Loring Brown, *View of Tivoli at Sunset*, 1848

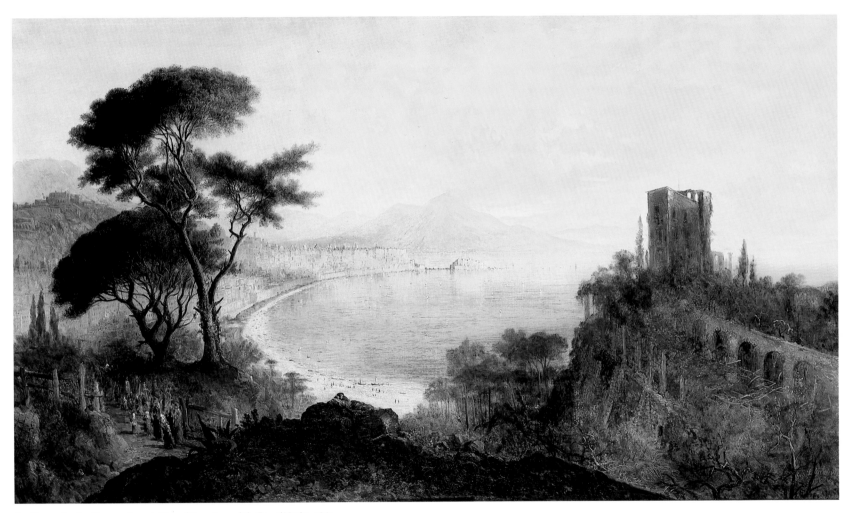

4 George Loring Brown, *Sunset, View of Vesuvius and the Bay of Naples*, 1864

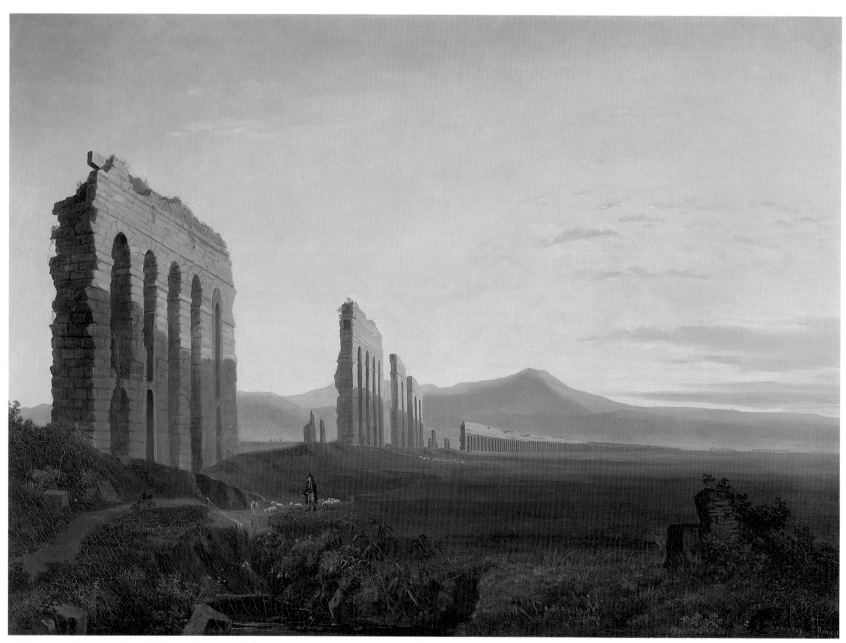

6 Benjamin Champney, *View of the Roman Campagna*, 1846

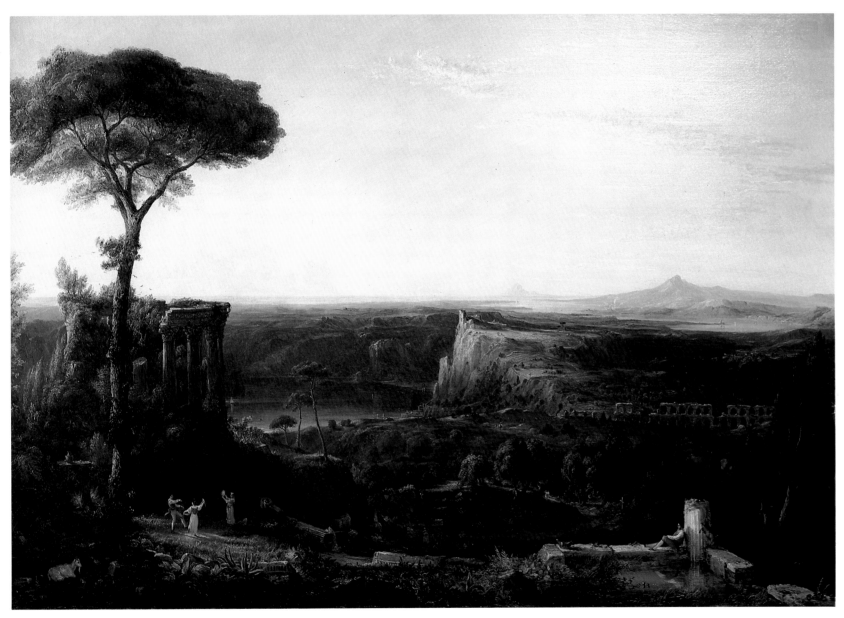

10 Thomas Cole, *Landscape Composition, Italian Scenery,* 1833

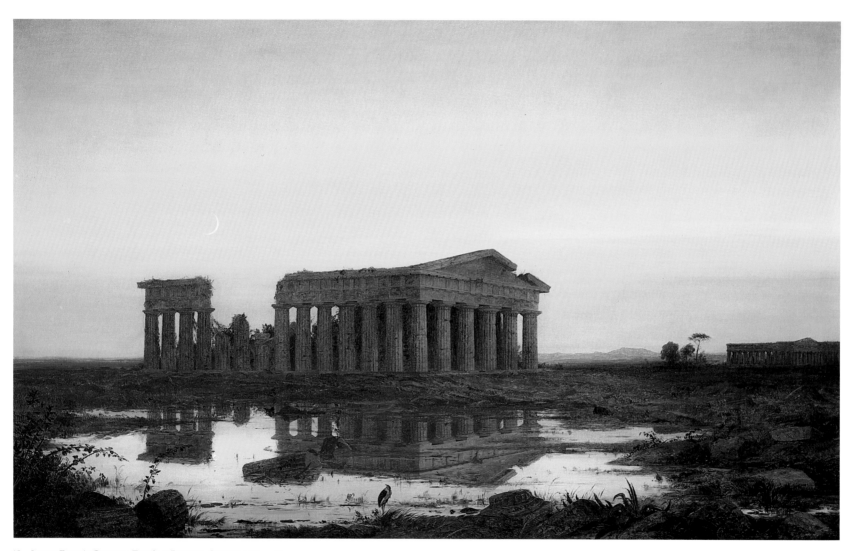

13 Jasper Francis Cropsey, *Temple at Paestum, Crescent Moon*, 1859

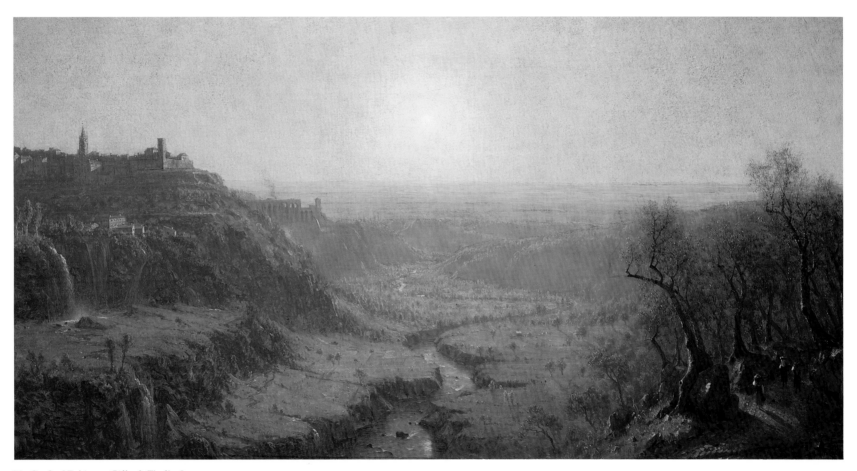

16 Sanford Robinson Gifford, *Tivoli*, 1870

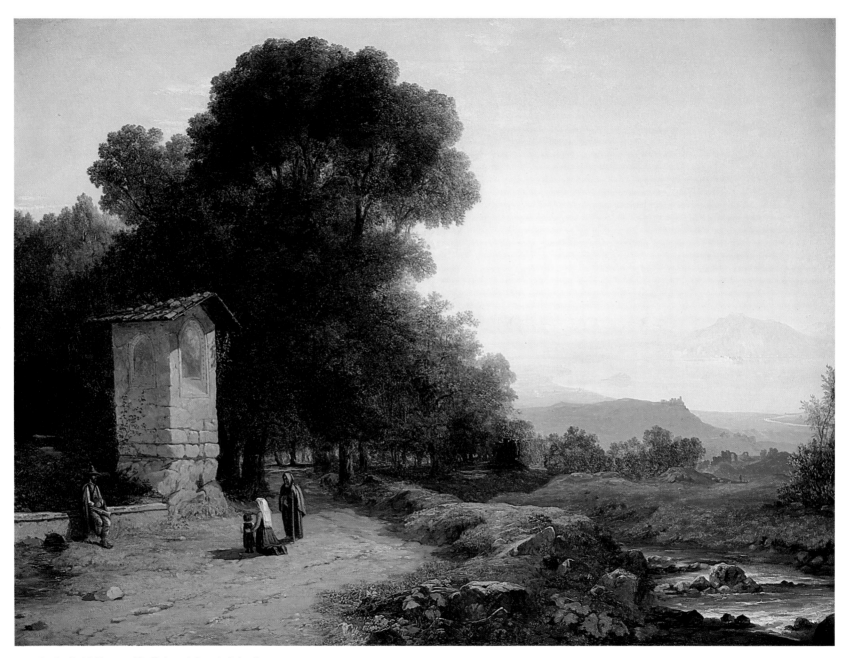

19 John Frederick Kensett, *The Shrine—A Scene in Italy,* 1847

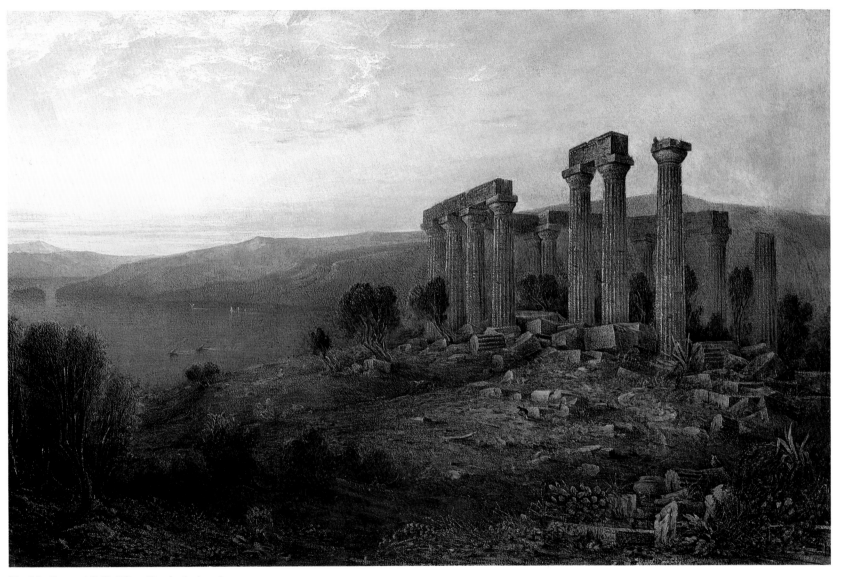

24 John Sargeant Rollin Tilton, *Temple, Aegina*, 1870s

Catalogue of the Exhibition

There is a wide, deep valley, the circuit of which is about three miles, and on one side, half way up the mountain, the town has been built. Beneath it, far below its foundations, the rocks are perforated by caverns, out of which and all around the circle of the romantic glen, the cascades come dashing forth, flinging their spray into the air. . . . Wilder scenes I have seen in my own land, yet never one uniting so much of the grandeur of nature with the soft and beautiful. The contrast is so striking, between the brilliant sunlight above, imparting an emerald tint to the vines and shrubs on which it rests, and the deep gloom of the gulf below.

William Ingraham Kip, *The Christmas Holydays in Rome*.

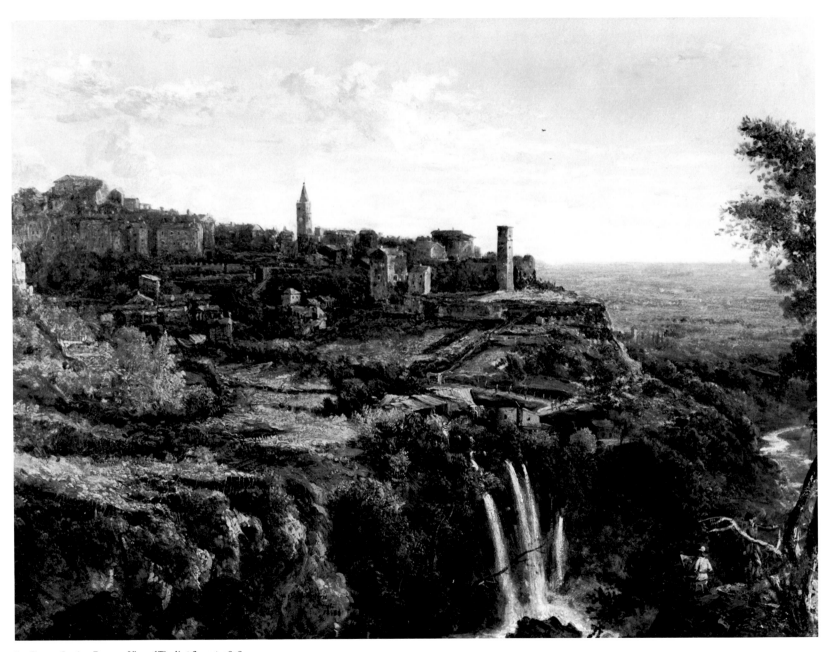

1 George Loring Brown, *View of Tivoli at Sunset*, 1848

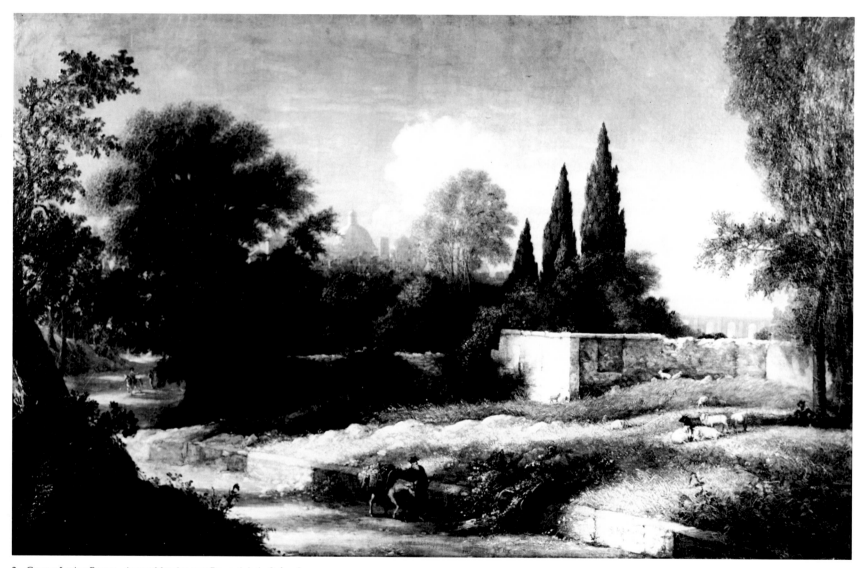

2 George Loring Brown, *August Morning near Rome, Ariccia, Italy*, 1855

3a George Loring Brown, *View near Rome*, 1854

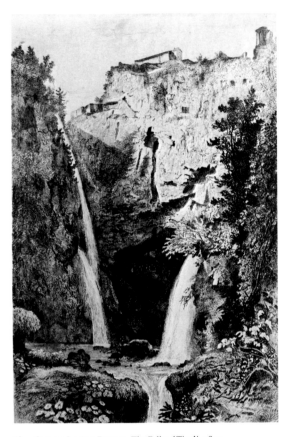

3b George Loring Brown, *The Falls of Tivoli*, 1854

3c George Loring Brown, *View in the Campagna near Genzano*, 1854

If you ascend from [Virgil's] tomb and turn Naples-ward from the crest of the hill, you have the loveliest view in the world of the sea and of the crescent beach, mightily jeweled at its further horn with the black Castel dell'Ovo. Fishermen's children are playing all along the foamy border of the sea, and boats are darting out into the surf. . . .

William Dean Howells, "Certain Things in Naples."

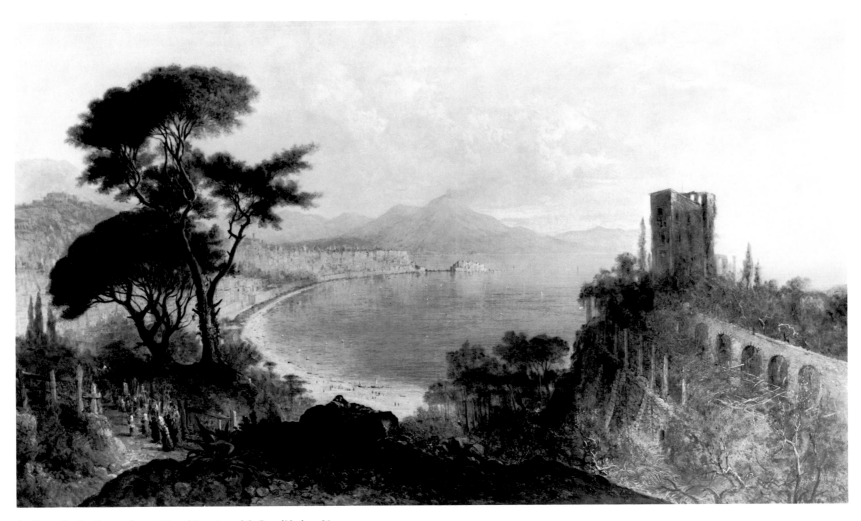

4 George Loring Brown, *Sunset, View of Vesuvius and the Bay of Naples*, 1864

O, Italy! my country, fare thee well!

 For art thou not my country, at whose breast

Were nurtured those whose thoughts within me dwell,

 The fathers of my mind! whose fame impress'd

E'en on my infant fancy, bade it rest

 With patriot fondness on thy hills and streams,

E'er yet thou didst receive me as thy guest,

 Lovelier than I had seen thee in my dreams?

Edmund D. Griffin, "Lines Written on Leaving Italy."

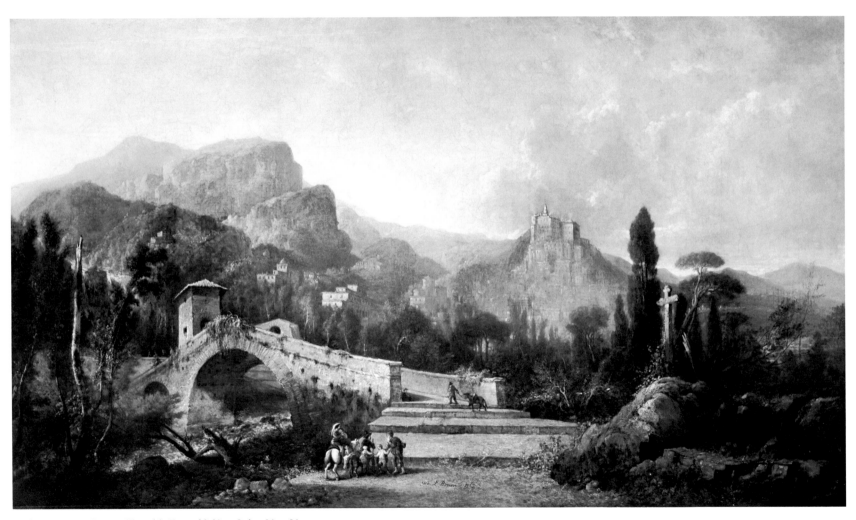

5 George Loring Brown, *View of the Town of Subiaco, Italy*, 1864–1865

Broken masses of ruins, shapeless and nameless, rise at intervals over its surface like surge-worn rocks on wintry shores. Deserted, tottering towers, once the abode of mediaeval violence, in ghost-like rigidity, cast melancholy shadows over the plain. Long lines of spectral fences lose themselves in the horizon. Far above them, majestic, sad, and lonely, here in solitary arches, there linked in stone embrace, continuous lines disappearing in perspective threads, the imperial aqueducts lift their graceful forms. Broken masses of light, fringed by stone-cast shadows, stream through the tall archways like rays of olden thought, or as though eternity opened its eyes upon time.

James Jackson Jarves, *Italian Sights and Papal Principles*.

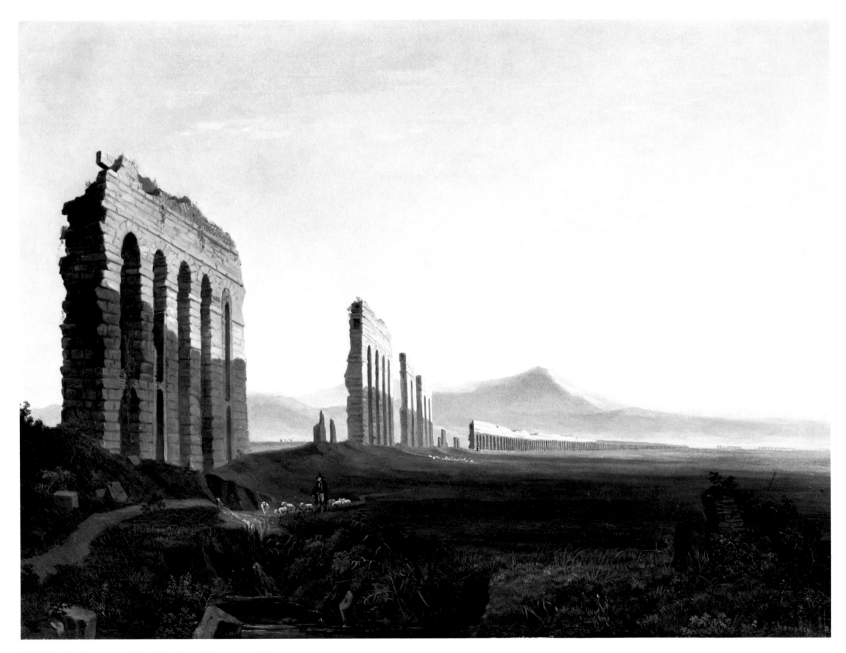

6 Benjamin Champney, *View of the Roman Campagna*, 1846

For several miles from Rome, the Appian Way was on both sides a great street of the dead. We devoted a day—a day of intense interest—to this monumental avenue, which we followed out five or six miles from Rome, in delightful weather, with a brilliant sun, whose very beams seemed however a little softened by a funereal shading; for they had shone upon the mausoleums when they were new and fresh, and they now glanced over their ruins. Alas for the hope of immortality to the name of man from any structures which he can erect!

Benjamin Silliman, *A Visit to Europe in 1851*.

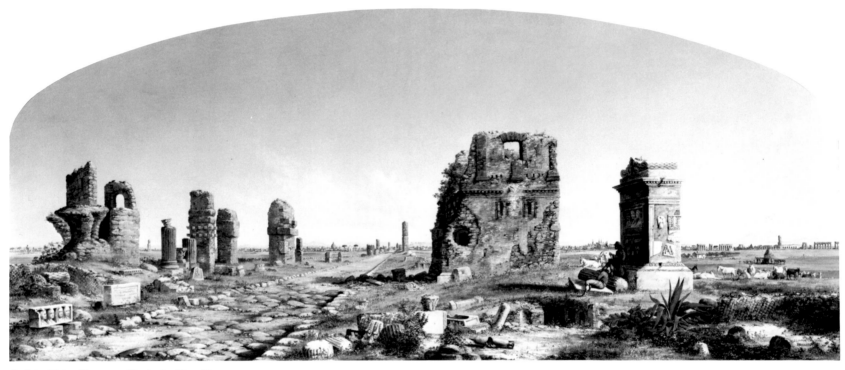

7 John Linton Chapman, *The Appian Way*, 1869

At your side, constantly, you have the broken line of the Claudian Aqueduct carrying its broad arches far away into the plain. . . . It stands knee-deep in the flower-strewn grass, and its rugged piers are hung with ivy, as the columns of a church are draped for a festa. Every archway is a picture, massively framed, of the distance beyond. . . . It is partly, doubtless, because their mighty outlines are still unsoftened that the aqueducts are so impressive. They seem the very source of the solitude in which they stand.

Henry James, "Roman Rides."

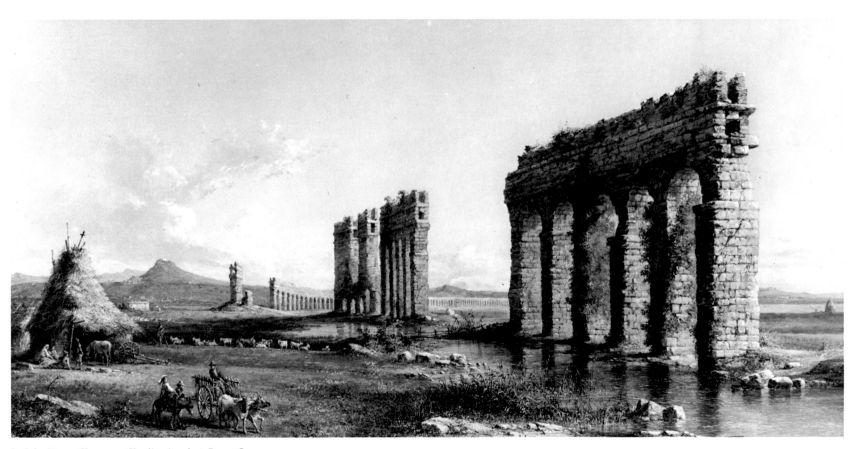

8 John Linton Chapman, *Claudian Aqueduct, Roman Campagna*

. . . when I stood in the Coliseum, its mountain-chains of ruins waving with foliage girding me round, the solitude was great and vast like that of savage nature, just such as one experiences when shut up in some great green hollow of the Apennine range, hemmed in by towering cliffs on every side.

Herman Melville, "Statues in Rome."

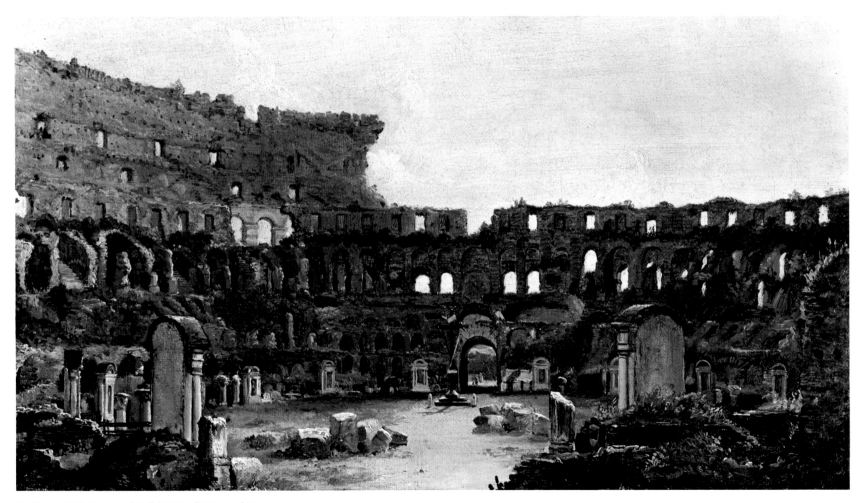

9 Thomas Cole, *Interior of the Colosseum, Rome*, ca. 1832

How bathes the desolation Nature's love

In flowing sunlight, and the tall grass waves,

Proud as the tresses on a Roman brow,

O'er all the crumbling fragments, buried deep.

And from the shadow of the graceful hills

A veil of silentness the twilight weaves,

And drapes the elder nations in the gray,

Departing presence of the Modern day.

William Ellery Channing, "The Campagna."

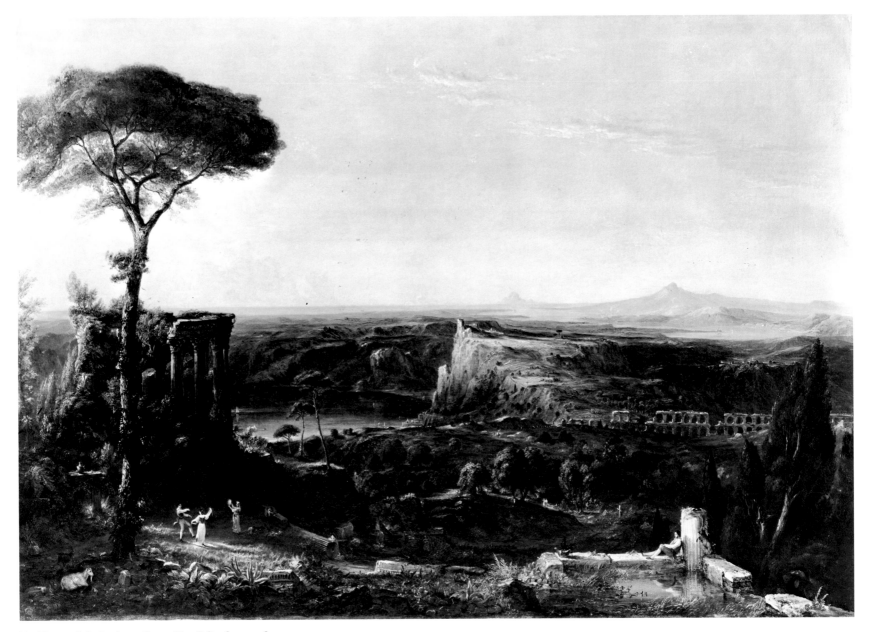

10 Thomas Cole, *Landscape Composition, Italian Scenery*, 1833

Type of the antique Rome! Rich reliquary
Of lofty contemplation left to Time
By buried centuries of pomp and power!
At length—at length—after so many days
Of weary pilgrimage and burning thirst,
(Thirst for the springs of lore that in thee lie,)
I kneel, an altered and an humble man,
Amid thy shadows, and so drink within
My very soul thy grandeur, gloom, and glory!

Edgar Allen Poe, "The Coliseum."

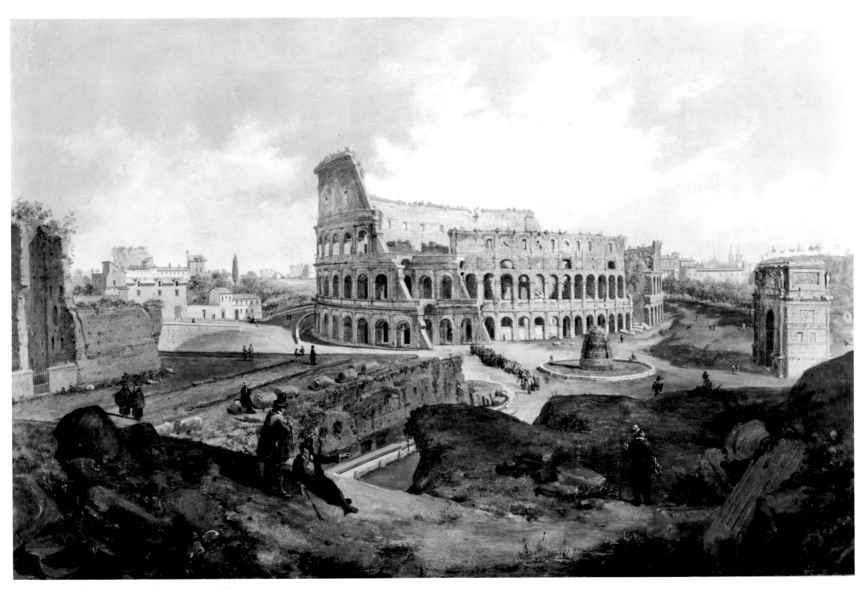

11 Jasper Francis Cropsey, *The Colosseum*, ca. 1848

Below the ruins of an Empire's pride

Make proud the dust with Caesared glory wed;

Rome cannot bury Rome, though time may hide

Her broken temples in a vulgar bed.

Still you may trace the arch triumphant spread;

Still many a column stands, like sculptured sigh,

To mourn the altar of a faith that's dead;

Something immortal yet seems hovering nigh,

For Gods will look divine, though passed into a lie.

Anon., "A Scene in Rome."

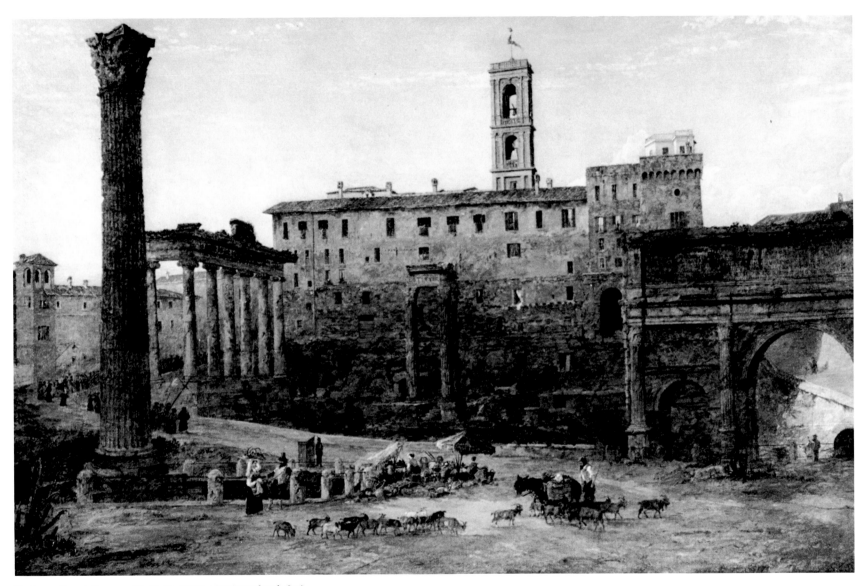

12 Jasper Francis Cropsey, *The Roman Forum*, 1849 (completed 1895)

As we approached them we could none of us resist the most enthusiastic exclamations of delight. Never had I seen anything more perfect, such exquisite proportions, such warm, rich coloring, such pictures- quely broken columns; flowers and briers growing in and around, and sometimes over fallen capitals. . . . And over all brooded such a silence and solitude. Nothing stood between us and the Past, to mar the impression. Mysterious, beautiful temples! Far in the desert, by the sea sands, in a country cursed by malaria, the only unblighted and perfect things—standing there for over two thousand years. It was almost like going to Greece.

Christopher Cranch, letter.

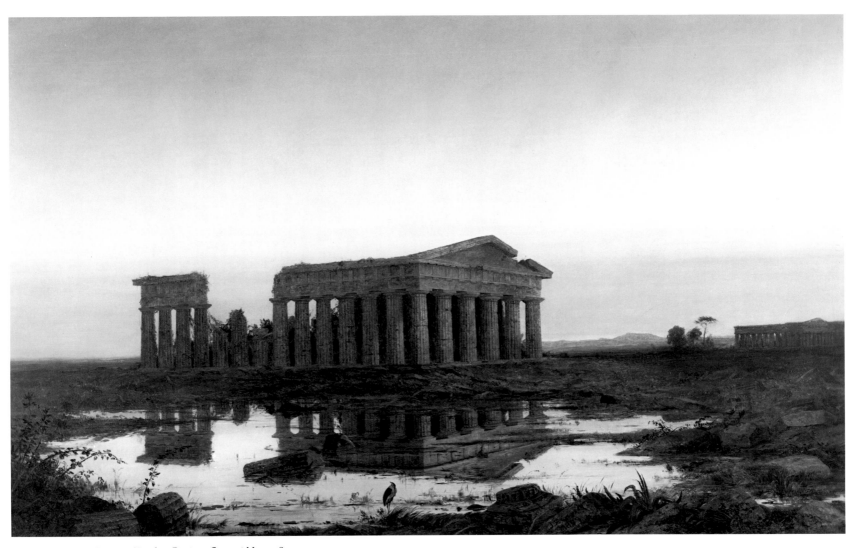

13 Jasper Francis Cropsey, *Temple at Paestum, Crescent Moon*, 1859

Shadows of centuries glide,
 Voiceless, around the scene—
Phantoms of power and pride,
 Gazing with mournful mien.
Temple and tomb and arch,
 Shattered and lonely stand;
Rent by the Vandal's march—
 Spoiled by the robber's hand!

. .

Yet, 'mid the waifs of Time
 Lingers the fame of old,
Calling, with voice sublime,
 Out from its temple's mould!

Bayard Taylor, "Rome."

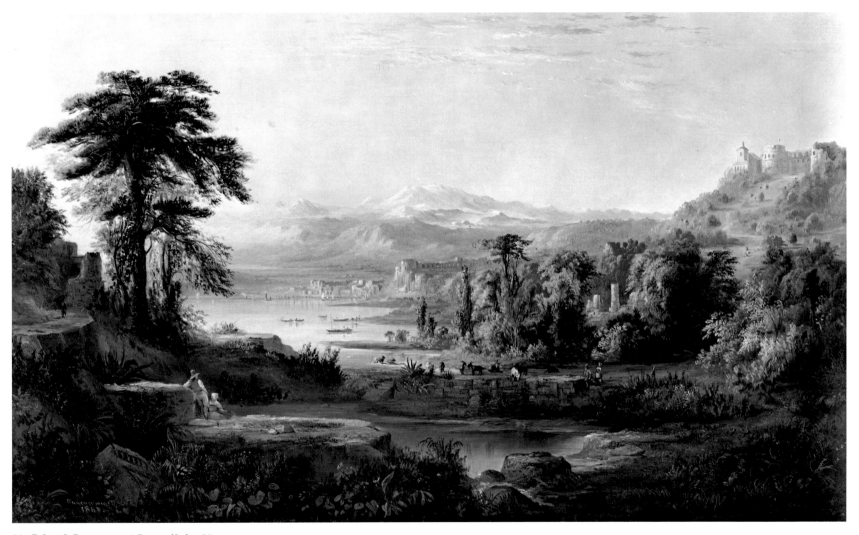

14　Robert S. Duncanson, *A Dream of Italy*, 1865

. . . no land of dreams, but the broadest page of history, crowded so full with memorable events that one obliterates another; as if Time had crossed and recrossed his own records till they grew illegible.

Nathaniel Hawthorne, *The Marble Faun*.

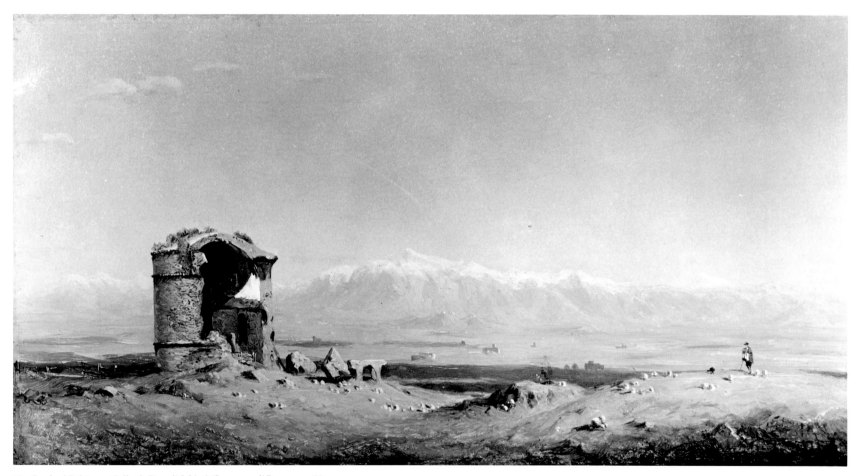

15 Sanford Robinson Gifford, *Torre di Schiavi, Campagna di Roma*, ca. 1864

Or is it that the fading light reminds

that we are mortal and the latter

steals onward swiftly, like the unseen winds,

And all our years are clouds that quickly pass away.

Thomas Cole, "Evening Thoughts."

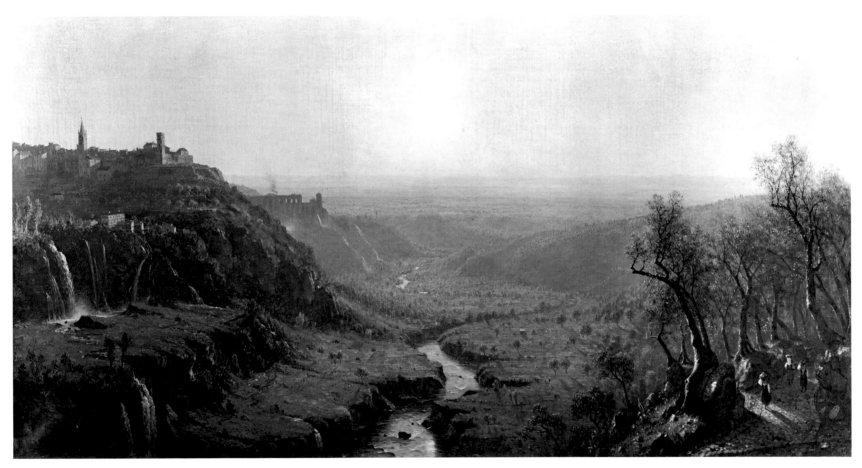

16 Sanford Robinson Gifford, *Tivoli*, 1870

My heart is in Italy, and has been ever since I left it. . . . I have seen too much of the world to expect impossibilities, but, being a sincere lover of nature, I could wish to die in Italy.

James Fenimore Cooper, letter to Horatio Greenough.

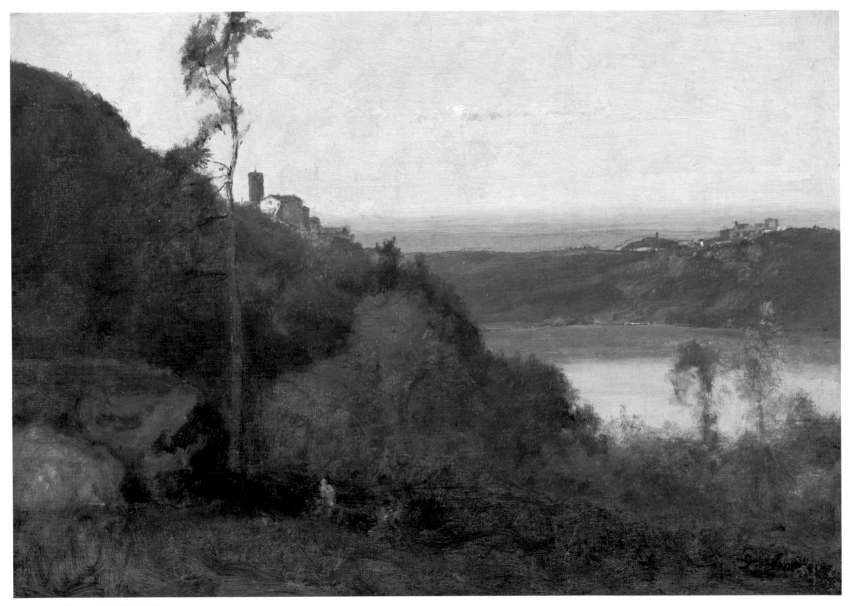

17 George Inness, *Lake Nemi*, 1872

Imperial City! I have dreamed of thee

 Through long, long years, since when, in early prime,

 I traced, with heart deep stirred, thy history

 Of men heroic, and of deeds sublime:

Thy storied names, which on the scroll of time

 But gather brightness with the flight of years;

 Or,—if all stained with tyranny and crime,

 With blood of slaughtered innocence and tears

Of bitter agony,—but blacker grow,

 As grows the detestation of mankind;

 Around thy Tiber, have availed to throw,

And o'er thy hills, where sits decay enshrined,

 A spell that warmed my soul with classic fire,

 And waked, to see thee, restless, keen desire!

Ray Palmer, "Farewell to Rome."

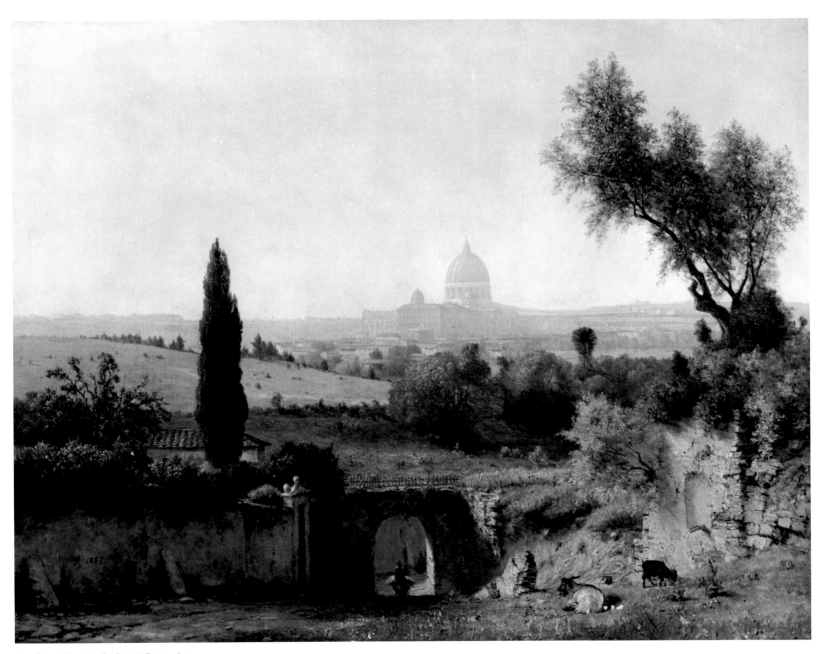

18 George Inness, *St. Peter's, Rome*, 1857

Sweet, sweet Italy! I can feel now how the soul may cling to thee, since thou canst thus gratify its insatiable thirst for the Beautiful. Even thy plainest scene is clothed in hues that seem borrowed of heaven! In the twilight, more radiant than light, and the stillness, more eloquent than music, which sink down over the sunny beauty of thy shores, there is a silent, intense poetry that stirs the soul through all its impassioned depths.

Bayard Taylor, *Views A-foot*.

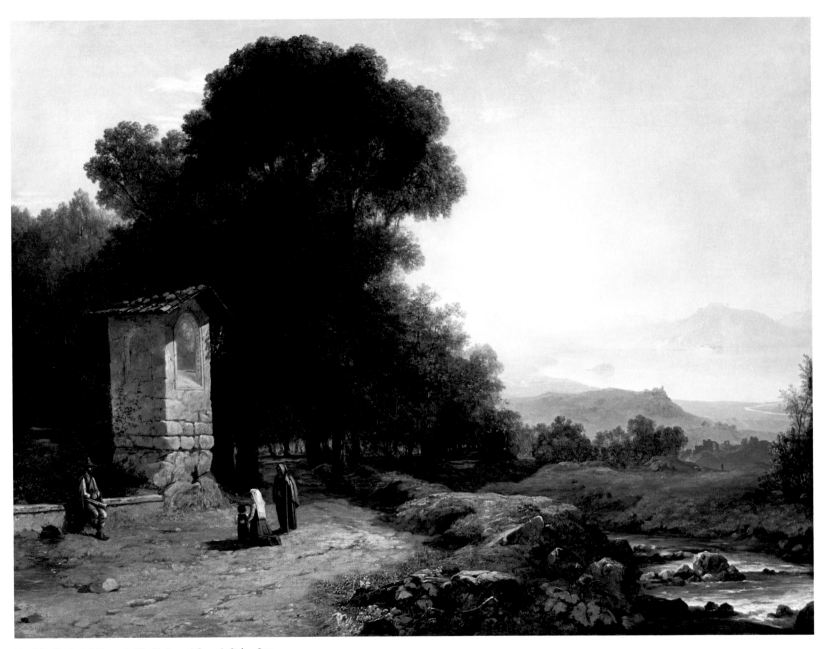

19 John Frederick Kensett, *The Shrine—A Scene in Italy,* 1847

Oh—vain as fair—thou fleeting light!

 Who now may in thy charms confide?

So shine Earth's pageants, false and bright,

 And pass like snails on ocean's tide.

In swift succession onward go

 To live and fall—day after day;

Thus human joys deceitful glow,

 And fade like waning light away.

E.F.E., "Sunset."

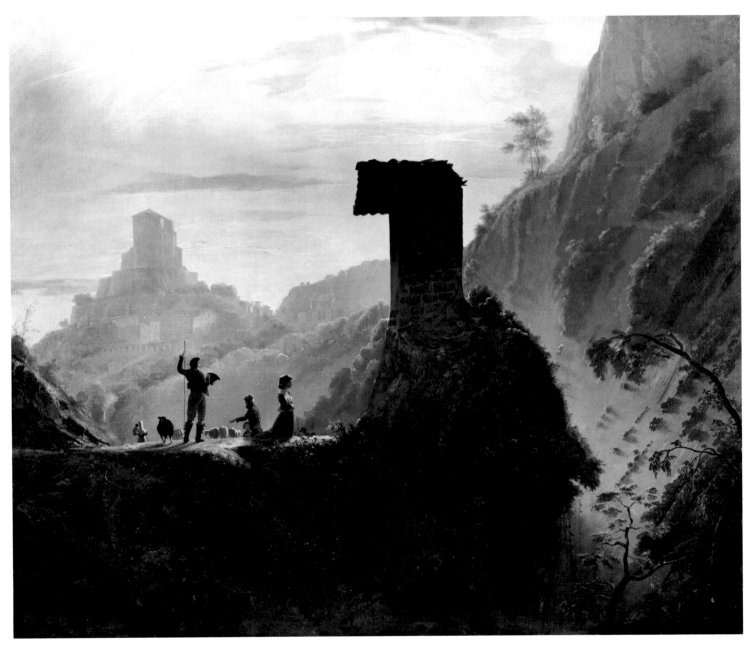

20 Samuel Finley Breese Morse, *Chapel of the Virgin at Subiaco*, ca. 1830–1831

To form a notion of Tivoli, we must imagine streams of falling water in all the forms which it can assume, leaping into hollows, gliding over inclined planes, or breaking into clouds of foam-dust, which glow with a thousand iridescent hues, smiting the eye with lines and points of metallic brightness. . . . Ruins must be set upon the very points where the eye asks for them. A general landscape of the noblest feature must be added; including a grand mountainous background, a wide horizon, and a broad plain into which, as into a sea of verdure, the jutting capes and headlands of the hillside project. Touch the heights with the gray mists of an antiquity five hundred years older than Rome, and throw over the whole a purple light drawn from the poetry of Horace, Catullus, and Propertius—and the result will be a dream of Tivoli.

George Stillman Hillard, *Six Months in Italy.*

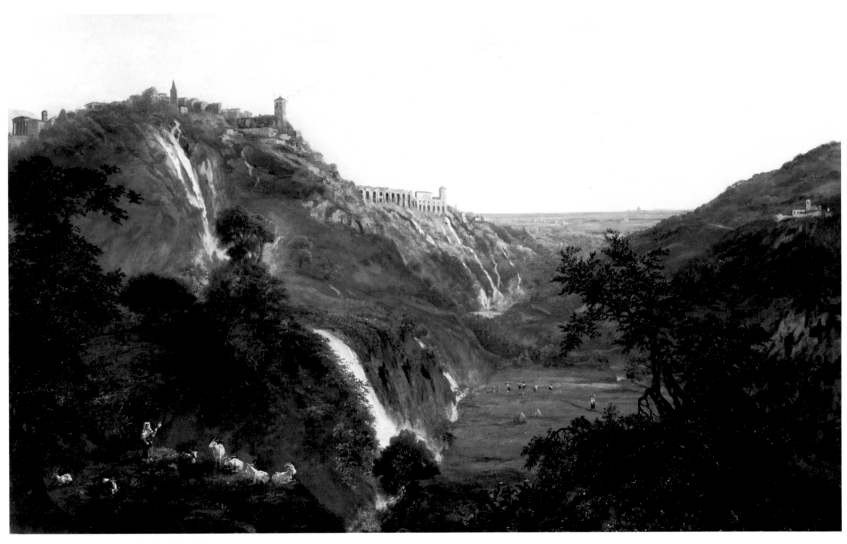

21 Joseph Ropes, *The Falls of Tivoli*, 1863–1864

All have pass'd away
Save the dead ruins, and the living robe
That nature wraps around them. Anxious fear,
High-swollen expectancy, intense despair,
And wild exulting triumph, here have reigned
And perished all.

Lydia H. Sigourney, "Rome."

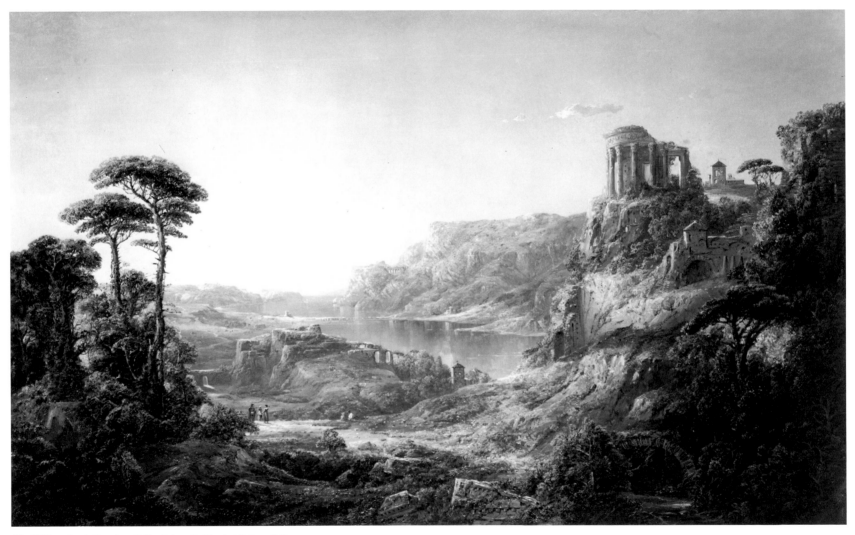

22 William Louis Sonntag, *Italian Lake with Classical Ruins*, 1858

'War, flood, and fire,' the earthquake's yawning mine,

Have batter'd, swept, and whelmed thy gorgeous halls;

Could all the blood within thee shed, combine,

'T would heave, a crimson deluge, o'er thy walls;

Now echo mocks my footstep as it falls,

Lonely, in Grandeur's desolate abodes;

My voice from covert dark the bat appals,

And oxen graze where the dank herbage nods

O'er earth's unsceptred kings, and dust of demi-gods!

J. Barber, "Rome: from the Capitoline Mount."

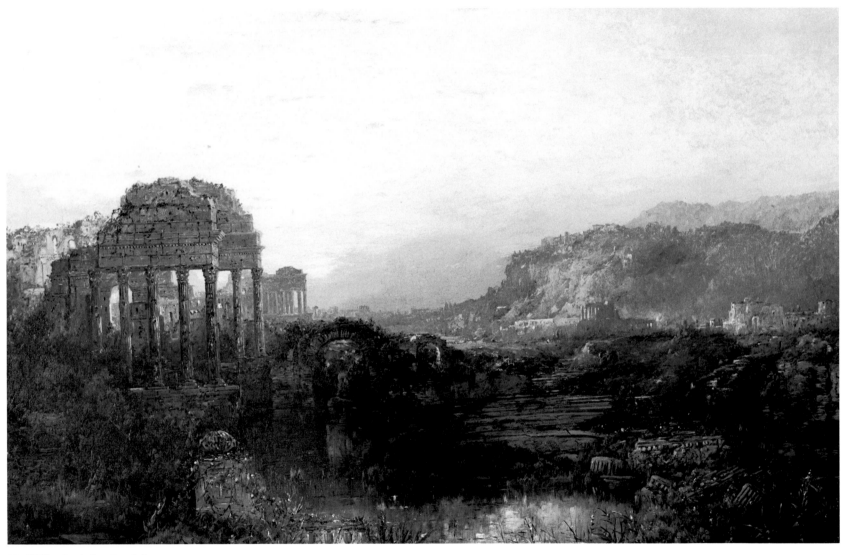

23 William Louis Sonntag, *Ruins*

'Twas late my lot to tread those ancient shores,
 Where now the Spirit of old inspiration
Mourns by the fount whose Nymph no longer pours
 A hallowed stream; and of a mighty nation—
Stemming in story, as the eagle soars
 Against the wind, the ebbing stream of time—
To mark the mountain birthplace and the grave;
The home of freedom trodden by the slave;
 The ruinous dwelling of that soul sublime,
Whose voice is silent now, on shore and wave,
 As it had never sounded—a mute thunder!
 But not the less we pause, in silent wonder,
By tomb, or temple, or old stream, or dell,
Where poet mused, sage thought, or patriot fell.

George Hill, "Recollections of Greece."

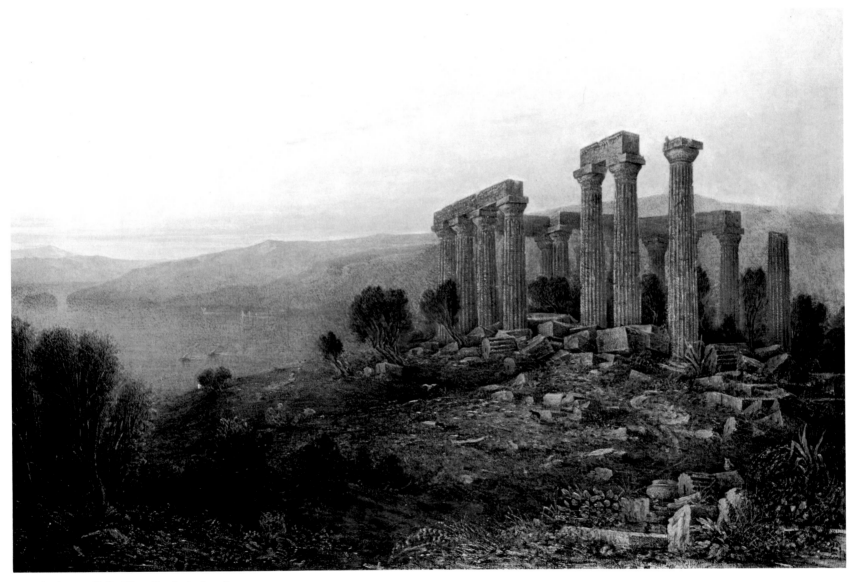

24 John Sargeant Rollin Tilton, *Temple, Aegina*, 1870s

From the great multitude of wondrous things, I would select the Colosseum as the object that affects me the most. It is stupendous, yet beautiful in its destruction. . . . It looks more like a work of nature than of man; for the regularity of art is lost, in a great measure, in delapidation. . . . To walk beneath its crumbling walls, to climb its shattered steps, to wander through its long, arched passages, to tread in the footsteps of Rome's ancient kings, to muse upon its broken height, is to lapse into sad, though not unpleasing meditation.

Thomas Cole, journal entry.

25 Attributed to John Sargeant Rollin Tilton, *The Roman Colosseum at Sunset*

26 Thomas Worthington Whittredge, *Roman Campagna*, 1857

Checklist

GEORGE LORING BROWN
Boston, Massachusetts 1814–1889 Malden, Massachusetts

A youthful aptitude for painting brought Brown to the attention of a Boston patron, who sponsored his first trip to Europe, from 1831 to 1834. In Paris he studied in the atelier of the landscapist Eugène Isabey and made expert copies after paintings in the Louvre. His copy after Claude much impressed Washington Allston, who encouraged Brown's return to Europe, especially to Italy. He left for Italy in 1840, remaining nineteen years. Isolated from the centers of modern American and European art, Brown evolved an antique, idiosyncratic style derivative of the Claudian tradition. This foreign manner, while appropriate for Old World scenery, proved to be too artificial for the New England wilderness. Long after his retirement to Massachusetts, Brown continued to paint lavish remembrances of Italy.

1 *View of Tivoli at Sunset*, 1848
Oil on canvas
14½ x 19¼ in. (36.8 x 48.9 cm)
Signed, dated, and inscribed at lower center: *G. L. Brown/Tivoli/ 1848*; on verso of canvas: *View of the town of Tivoli at Sunset/ painted from Nature by/G.L. Brown 1848*
D. Wigmore Fine Art, Inc., New York

2 *August Morning near Rome, Ariccia, Italy*, 1855
Oil on canvas
35 x 55¾ in. (88.9 x 141.5 cm)
Signed at lower right: *G.L. Brown*; on verso of canvas: *"August Morning"/View at Arriccia [sic], Nr Rome;/Painted by—/G.L. Brown/Rome 1855*
Mead Art Museum, Amherst College, Amherst, Massachusetts
Gift of Mr. Herbert W. Plimpton
The Hollis W. Plimpton '15 Memorial Collection

3a *View near Rome*, 1854
Etching
Plate: 5¹³⁄₁₆ x 8⅝ in. (14.9 x 22.1 cm)
Signed, dated, and inscribed on plate at lower center: *G. L. Brown Rome, 1854*
Bowdoin College Museum of Art, Brunswick, Maine
Lloyd O. and Marjorie Strong Coulter Fund

3b *The Falls of Tivoli*, 1854
Etching
Plate: 8⅜ x 5⅞ in. (21.3 x 14.9 cm)
Signed, dated, and inscribed on plate at lower right: *G. L. Brown/Rome/1854*
Bowdoin College Museum of Art, Brunswick, Maine
Hamlin Fund

3c *View in the Campagna near Genzano*, 1854
Etching
Plate: 5⅜ x 7¹⁵⁄₁₆ in. (13.7 x 20.2 cm)
Signed, dated, and inscribed on plate at lower left: *G. L. Brown/ Rome/1854*; at upper left: *3*; below image at center: *G. W. H. Ritchie Imp.*
Bowdoin College Museum of Art, Brunswick, Maine
Lloyd O. and Marjorie Strong Coulter Fund

4 *Sunset, View of Vesuvius and the Bay of Naples*, 1864
Oil on canvas
34⅛ x 60¼ in. (88.7 x 153.0 cm)
Signed, dated, and inscribed at lower right: *Geo. L. Brown/1864*; on verso of canvas: *"Sunset"/View of Vesuvius, & Bay of NAPLES, & City/(taken from Virgils Tomb) & Old Convent of St Maria/and Religious Procession of the Corpus Domini —/by Geo. L Brown/1864*
Bowdoin College Museum of Art, Brunswick, Maine
Bequest of Joseph E. Merrill, Class of 1854

5 *View of the Town of Subiaco, Italy,* **1864–1865**
 Oil on canvas
 34 x 59¾ in. (86.4 x 151.8 cm)
 Signed and dated at lower center: *Geo. L. Brown–1865*
 Hood Museum of Art, Dartmouth College, Hanover, New
 Hampshire
 Gift of Annie B. Dore

BENJAMIN CHAMPNEY
New Ipswich, New Hampshire 1817–1907 Woburn, Massachusetts

A minor painter, the friend of many major painters, Champney is
best remembered for his scenic vistas of the White Mountains. As a
young man he followed the tide of artists overseas, remaining
abroad for five years (1841–1846). In Paris he met John Kensett, with
whom he journeyed to Italy in 1845. They passed the winter season
in Rome, where they fell in with a "jolly crowd" of American artists
then in residence. Champney's paintings from this period reveal
how diligently he learned and applied the principles of the arcadian
landscape.

6 *View of the Roman Campagna,* **1846**
 Oil on canvas
 31 x 43¼ in. (78.7 x 109.6 cm)
 Signed, dated, and inscribed at lower right: *B. Champney, Rome
 1846*
 Yale University Art Gallery, New Haven, Connecticut

JOHN LINTON CHAPMAN
Washington, D.C. 1839/40–1905 Westchester, New York

One of the more obscure of the American artists in Rome, Chapman
probably learned painting from his expatriate father, the now
equally obscure John Gadsby Chapman (1808–1889). From 1848 to
1878 he lived abroad, principally in Rome and Florence. Catering to
the tourist market, Chapman specialized in souvenir pictures of
popular sights. Meticulously, almost clinically observed, his land-
scapes suggest the influences of photography and John Ruskin.

Back in New York, Chapman continued to produce Italian scenes—
mainly variations on earlier compositions, sized for every budget.

7 *The Appian Way,* **1869**
 Oil on canvas
 29⅜ x 71⅝ in. (74.6 x 181.9 cm)
 Signed, dated, and inscribed at lower right: *J. LINTON CHAP-
 MAN./ROMA./1869*; on verso of canvas: *Via Appia/painted for
 Silas C. Herring, Esq. N.Y./by J. Linton Chapman. Roma. 1869*
 The Brooklyn Museum, Brooklyn, New York
 The Roebling Fund, Carll H. De Silver Fund, Caroline H.
 Polhemus Fund, A. Augustus Healy Fund, Frederick Loeser
 Fund

8 *Claudian Aqueduct, Roman Campagna*
 Oil on canvas
 14 x 28 in. (37.6 x 71.1 cm)
 Signed at lower left: *J. Linton Chapman*
 D. Wigmore Fine Art, Inc., New York

THOMAS COLE
Bolton-le-Moor, Lancashire, England 1801–1848 Catskill, New York

Born in England, Cole arrived in America at the age of eighteen. Like
many immigrants, he was an ardent patriot, and he became a
zealous champion for a native school of landscape painting that
would celebrate the yet unclaimed promise of the New World. Even
so, Cole was no isolationist. He made two return trips to Europe
(1829–1832 and 1841–1842), likening his study of the "Great Masters"
to a test of combat. The history-laden scenery of Europe challenged
Cole's imagination as much as the art did. Italy haunted him. The
physical and moral decline of imperial Rome became a recurring
subject and metaphor in his art, achieving extravagant expression in
The Course of Empire.

9 *Interior of the Colosseum, Rome,* **ca. 1832**
 Oil on canvas
 10 x 18 in. (25.4 x 45.7 cm)
 Albany Institute of History and Art, Albany, New York

10 *Landscape Composition, Italian Scenery,* **1833**
Oil on canvas
37½ x 54½ in. (95.0 x 138.0 cm)
Signed at left of bottom center: *T.C.*
The New-York Historical Society, New York

JASPER FRANCIS CROPSEY
Staten Island, New York 1823–1900 Hastings-on-Hudson, New York

Cropsey abandoned a promising career in architecture to devote himself to landscape painting. He inherited Thomas Cole's passion for flamboyant pictorial statement, most evident in his high-keyed compositions of autumnal scenery. Even before his first trip abroad he was painting Italianate landscapes, either imagined or copied. From 1847 to 1849 he toured Europe, spending more than a year in Italy. While he lived in Rome, where he occupied Cole's former studio, Cropsey made numerous sketching excursions through the central and southern parts of the peninsula. Revolutionary turmoil in the city prompted his return to America. Over the next decade, he frequently painted Italian subjects recollected from detailed sketches.

11 *The Colosseum,* **ca. 1848**
Oil on canvas
20 x 32 in. (50.0 x 81.0 cm)
Signed and inscribed at lower right: *J.F.C. Roma*
The Newington-Cropsey Foundation, Greenwich, Connecticut

12 *The Roman Forum,* **1849 (completed 1895)**
Oil on canvas
33 x 40 in. (83.0 x 101.0 cm)
Signed, dated, and inscribed on label affixed to verso of canvas:
The Roman Forum, in 1849/by J.F. Cropsey, N.A./Hastings-upon-Hudson,/N.Y./Began in Rome 1849 and/finished at Hastings in 1895
The Newington-Cropsey Foundation, Greenwich, Connecticut

13 *Temple at Paestum, Crescent Moon,* **1859**
Oil on canvas
30 x 50 in. (76.0 x 127.0 cm)
Signed and dated at right of bottom center: *J.F. Cropsey/1859*
The Newington-Cropsey Foundation, Greenwich, Connecticut

ROBERT S. DUNCANSON
New York State 1817 or 1821/22–1872 Detroit, Michigan

The son of a racially mixed marriage, Duncanson pursued a career outside the mainstream of American art. Though he studied the landscapes of Thomas Cole and the Hudson River school, his own style reflected a pronounced orientation towards Europe. Duncanson first went overseas in 1853 on a trip sponsored by Cincinnati art patrons and abolitionists. Accompanied by William Sonntag, he toured Britain, France, and Italy. Greatly admiring the English landscape painters, particularly Turner, he incorporated their poetic fusion of imagined space and factual description into his own landscapes. This is most apparent in his numerous Italian "dreamscapes." Two subsequent trips abroad (1863–1867 and 1870–1871) confirmed Duncanson's reliance on European pictorial formulas.

14 *A Dream of Italy,* **1865**
Oil on canvas
21 x 32 in. (53.0 x 81.0 cm)
Signed and dated at lower left: *Duncanson/1865*
Private Collection
Courtesy of Berry-Hill Galleries, New York

SANFORD ROBINSON GIFFORD
Greenfield, New York 1823–1880 New York, New York

Among the second generation of Hudson River school painters, Gifford was the most acutely attuned to the poetics of light and atmosphere. For him light was the transcendent, unifying element of nature. And it was the dissolving radiance of Italian sunlight that most enriched his European experience. Gifford made his first trip

abroad in 1855–1857, spending a winter in Rome with Worthington Whittredge and Albert Bierstadt. In 1868 he revisited Italy on his way to the eastern Mediterranean. In contrast to Thomas Cole Gifford had only a tourist's passing interest in the historical import of a scene. What truly mattered to him was the spiritual presence of the landscape as awakened by light.

15 *Torre di Schiavi, Campagna di Roma*, **ca. 1864**
Oil on canvas
8½ x 15¾ in. (21.0 x 40 cm)
Henry Melville Fuller, New York

16 *Tivoli*, **1870**
Oil on canvas
26⅜ x 50⅜ in. (67.0 x 128.0 cm)
Signed and dated at lower right: *S.R. Gifford, 1870*; on verso of
 canvas: *Tivoli/S.R. Gifford pinxit/1870.*
The Metropolitan Museum of Art, New York
Gift of Robert Gordon, 1912

GEORGE INNESS
near Newburgh, New York 1825–1894 Bridge of Allan, Scotland

Among the painters who divided the romantic legacy of Thomas Cole, Inness was the most stubbornly independent. Though he shared Cole's reverence for nature, he preferred it civilized, the realm of men, not gods. Partly for this reason, he sympathized more with the European perceptions of nature as expressed in the landscapes of Claude, Hobbema, and the French Barbizon school. When Inness first came to Rome in 1852, it was as a student. His paintings from this period exhibit the diversity of styles and attitudes then prevalent in the city. He returned to Italy in 1870 as a master in mid-career. Although his choice of subjects was dictated somewhat by commercial considerations, he vividly reimagined the familiar scenery, downplaying the customary rhetoric of wrack and ruin for a more elusive, personal interpretation of place.

17 *Lake Nemi*, **1872**
Oil on canvas
12¼ x 18¼ in. (30.0 x 46.0 cm)
Signed at lower right: *G. Inness*
Museum of Fine Arts, Boston, Massachusetts
Charles Henry Hayden Fund

18 *St. Peter's, Rome*, **1857**
Oil on canvas
30 x 40 in. (76.2 x 101.6 cm)
Signed and dated at lower left: *I 1857*
The New Britain Museum of American Art, New Britain,
 Connecticut
Charles F. Smith Fund

JOHN FREDERICK KENSETT
Cheshire, Connecticut 1816–1872 New York, New York

Soon after conceiving the ambition to be a landscape painter, Kensett made the expected pilgrimage to Europe. From 1840 to 1847 he lived abroad, plunging into the fluid, volatile society of *la vie de bohème*. In the galleries of Paris and London he paid honor to the old masters, especially Claude, whom he reverently copied. As it had for many artists, Claude's lyric vision informed Kensett's perceptions of Italy. But the American needed no interpreter to appreciate the splendor of Italian light. It pervades his landscapes, anticipating the luminism of the artist's mature American paintings.

19 *The Shrine—A Scene in Italy*, **1847**
Oil on canvas
30⅜ x 41⅝ in. (77.1 x 105.7 cm)
Signed, dated, and inscribed at lower right: *J. F. Kensett, Rome,
 1847*
Mr. and Mrs. Maurice N. Katz, Naples, Florida

SAMUEL FINLEY BREESE MORSE

Charlestown, Massachusetts 1791–1872 New York, New York

The son of a prominent Congregational minister, Morse early decided upon a career as a portrait and history painter. In 1811 he accompanied Washington Allston to London, where he studied briefly with the elderly Benjamin West. He intended to continue his studies in Italy, but money problems and family commitments forced him to wait nearly twenty years. In 1829 Morse returned to Europe, financing his travels with prepaid commissions for copies after the old masters. He spent a profitable year in Italy, principally in Rome. Openly contemptuous of the modern city, Morse was captivated by the unspoiled scenery of the surrounding hill towns, which inspired a rare venture into landscape painting.

20 *Chapel of the Virgin at Subiaco*, ca. 1830–1831
 Oil on canvas
 29¹⁵⁄₁₆ x 37 in. (75.0 x 93.0 cm)
 Inscribed on stretcher: *Chapel of the Virgin at Subiaco by Morse for
 Stephen Salisbury, Esq.*
 Worcester Art Museum, Worcester, Massachusetts
 Bequest of Stephen Salisbury III

JOSEPH ROPES

Salem, Massachusetts 1812–1885 New York, New York

Ropes was a shy man about whom little was known even in his own day. By the mid–1850s he is mentioned in Italy; a contemporary reports him "settled in Rome," where he stayed about ten years. Long residency abroad erased whatever was native in Ropes's style. His Italian scenes, of which few appear to have survived, are conventionally composed, competently painted, and virtually indistinguishable from the commercial views of other expatriate artists.

21 *The Falls of Tivoli*, 1863–1864
 Oil on canvas
 28¾ x 46¾ in. (73.0 x 118.0 cm)

Signed, dated, and inscribed on verso of canvas: *J. Ropes/Tivoli/
 Rome, 1863–4*
The Currier Gallery of Art, Manchester, New Hampshire
Gift of Mrs. Eunice Bohanon

WILLIAM LOUIS SONNTAG

East Liberty, Pennsylvania 1822–1900 New York, New York

Presumably self taught, Sonntag first distinguished himself with an 1847 pictorial cycle chronicling *The Progress of Civilization*, a clear echo of Thomas Cole's *Course of Empire*. In 1853, he accompanied Robert Duncanson to Europe. Italy left an indelible impression on both men. Sonntag returned several times over the next decade and even contemplated permanent residence there. His affection for Italy expressed itself in a series of idyllic landscapes composed of remembered elements of architecture and picturesque scenery, the whole veiled in twilight.

22 *Italian Lake with Classical Ruins*, 1858
 Oil on canvas
 35¾ x 60 in. (42.0 x 72.5 cm)
 Dated at lower left: '58
 Hood Museum of Art, Dartmouth College, Hanover,
 New Hampshire
 Gift of Annie B. Dore

23 *Ruins*
 Oil on canvas
 22 x 36 in. (55.0 x 91.0 cm)
 Signed at lower left corner: *W.L. Sonntag*
 Lyman Allyn Museum, New London, Connecticut

JOHN SARGEANT ROLLIN TILTON

Loudon, New Hampshire 1828–1888 Rome, Italy

On the strength of his work as a decorator of railway cars, Tilton was urged to become a landscape painter by Maine art critic and novelist

John Neal. Early successes, including a copy after Thomas Cole's *Roman Aqueducts*, encouraged him to go abroad in 1852. He settled permanently in Rome, where he was a prominent, if eccentric, fixture in the expatriate community, the object of derisive humor. Called "Tintoretto," Tilton obsessively studied the manner and methods of the Renaissance Venetians. His artful and self-consciously anachronistic landscapes enjoyed a brief vogue among American and English tourists but fell far out of fashion after the American Civil War. By 1880 critics scorned his paintings as guidebook curiosities.

24 *Temple, Aegina*, 1870s
Oil on canvas
30¾ x 48 in. (78.0 x 121.9 cm)
Signed at lower right corner with hieroglyphs
Bowdoin College Museum of Art, Brunswick, Maine
Gift of the Misses Harriet and Sophia Walker

25 *The Roman Colosseum at Sunset* (attributed to Tilton)
Oil on canvas
30¼ x 40 in. (76.8 x 101.6 cm)
Dr. Henry A. Camperlengo, Albany, New York

THOMAS WORTHINGTON WHITTREDGE
near Springfield, Ohio 1820–1910 Summit, New Jersey

Encouraged by the support of Cincinnati patrons, Whittredge sailed for Europe in 1849, not returning until ten years later. He studied in Paris and Düsseldorf and spent four winters in Rome. His Roman landscapes document frequent sketching forays in the Campagna and surrounding hills. Though the subjects were common to the repertoire of many painters, Whittredge treated them with unusual candor, eschewing romance for the frank appreciation of the natural setting. Despite his later claims that he learned nothing from his foreign travels, it is evident that Whittredge attained maturity as a landscape painter in Italy.

26 *Roman Campagna*, 1857
Oil on canvas
24 x 39 in. (60.0 x 99.0 cm)
Signed at lower left: *W. Whittredge Rome 1857*
Denison Burton, Chatham, New Jersey

Bibliographies

GENERAL BIBLIOGRAPHY

Adams, Henry. *The Education of Henry Adams*. New York: The Library of America, 1983.

"American Artists Abroad." *Kennedy Quarterly* 8 (1968). New York: Kennedy Galleries.

Armstrong, Maitland. *Day before Yesterday: Reminiscences of a Varied Life*. Ed. by Margaret Armstrong. New York: Charles Scribner's Sons, 1920.

"The Artistical Directory; or Guide to the Studios of the Italian and Foreign Painters and Sculptors Resident in Rome." Rome, 1857.

Baker, Paul R. *The Fortunate Pilgrims: Americans in Italy, 1800–1860*. Cambridge: Harvard University Press, 1964.

Benjamin, S. G. W. *Art in America: A Critical and Historical Sketch*. New York: Harper Brothers, 1880.

Brooks, Van Wyck. *The Dream of Arcadia: American Writers and Artists in Italy, 1760–1915*. New York: E. P. Dutton, 1958.

Bryant, William Cullen. *Letters of a Traveller; or, Notes of Things Seen in Europe and America*. New York: G. P. Putnam, 1850.

Calvert, George Henry. *Scenes and Thoughts in Europe*. New York: Wiley and Putnam, 1846.

Channing, William Ellery. *Conversations in Rome: Between an Artist, a Catholic and a Critic*. Boston: Wm. Crosby & H. P. Nichols, 1847.

Cole, Thomas. *The Collected Essays and Prose Sketches*. Ed. by Marshall Tymn. St. Paul, Minn.: The John Colet Press, 1980.

Cooper, James Fenimore. "American and European Scenery Compared." *The Home Book of the Picturesque*. New York: G. P. Putnam, 1852, 51–69.

Cox, Samuel S. *A Buckeye Abroad*. New York: G. P. Putnam, 1852.

Dewey, Orville. *The Old World and the New, or, A Journal of Reflections and Observations Made on a Tour in Europe*. 2 vols. New York: Harper & Brothers, 1836.

Dinnerstein, Lois. "The Significance of the Colosseum in the First Century of American Art." *Arts* 58 (June 1984): 116–120.

Dunlap, William. *History of the Rise and Progress of the Arts of Design in the United States*. 2 vols. New York, 1834. Reprint, ed. by Rita Weiss, introduction by James T. Flexner. New York: Dover, 1969.

Earnest, Ernest. *Expatriates and Patriots: American Artists, Scholars, and Writers in Europe*. Durham, N.C.: Duke University Press, 1968.

Eldredge, Charles C., and Novak, Barbara. *The Arcadian Landscape: Nineteenth-Century American Painters in Italy*. Exh. cat. Lawrence: University of Kansas Museum of Art, 1972.

"Florentia." "The Artists' Festa: Rome." *The Art-Journal* (London) 6 (n.s.) (1854): 271–273.

"Florentia." "A Walk Through the Studios of Rome." *The Art-Journal* (London) 6 (n.s.) (1854): 184–187, 287–289, 322–324, 350–355; 7 (1855): 225–228.

Freeman, James E. *Gatherings from an Artist's Portfolio in Rome*. Boston: Roberts Brothers, 1883.

Gibbes, Robert W. *A Memoir of James De Veaux of Charleston, S.C.* Columbia, S.C., 1846.

Greene, George Washington. "Letters from Rome," *The Knickerbocker* 15 (June, 1840): 488–496; 18 (November, 1841): 371–378.

A Handbook of Rome and Its Environs. 5th ed. London: John Murray, 1858.

Hawthorne, Nathaniel. *The French and Italian Notebooks*. Ed. by Thomas Woodson. Vol. 14 of *The Centenary Edition of the Works of Nathaniel Hawthorne*. Columbus: Ohio State University Press, 1980.

Hawthorne, Nathaniel. *The Marble Faun*. Included in *Novels*. Ed. by Millicent Bell. New York: The Library of America, 1983.

Hawthorne, Sophia Amelia Peabody. *Notes in England and Italy*. New York: G. P. Putnam & Son, 1869.

Hillard, George Stillman. *Six Months in Italy*. 2 vols. Boston: Ticknor, Reed, and Fields, 1853.

Howells, William Dean. *Italian Journeys*. Boston and New York: Houghton Mifflin, 1867.

James, Henry. "Daisy Miller: A Study." *The Complete Tales of Henry James*. Ed. by Leon Edel. Vol. 4. London: Rupert Hart-Davis, 1962, 141–207.

James, Henry. "From a Roman Notebook." *The Galaxy* 16 (November 1873): 679–686.

James, Henry. *Roderick Hudson*. Included in *Novels, 1871–80*. Ed. by William T. Stafford. New York: The Library of America, 1983.

James, Henry. "Roman Rides." *The Atlantic Monthly* 32 (August 1873): 190–198.

James, Henry. *William Wetmore Story and His Friends*. 2 vols. Boston: Houghton Mifflin, 1903.

Jarves, James Jackson. *Art-Hints*. New York: Harper & Brothers, 1855.

Jarves, James Jackson. *The Art-Idea*. New York: Hurd and Houghton, 1864. Reprint, ed. by Benjamin Rowland, Jr. Cambridge, Mass.: Harvard University Press, The Belknap Press, 1960.

Kip, William Ingraham. *The Christmas Holydays in Rome*. New York: D. Appleton, 1845.

Lester, Charles Edward. *The Artists of America*. New York: Baker & Scribner, 1846.

Norton, Charles Eliot. *Notes of Travel and Study in Italy*. Boston: Houghton Mifflin, 1859.

Novak, Barbara. *Nature and Culture: American Landscape and Painting, 1825–1875*. New York: Oxford University Press, 1980.

O'Doherty, Barbara Novak, "Thomas H. Hotchkiss, An American in Italy." *Art Quarterly* 29 (Summer 1966): 3–28.

Park, Roswell. *A Hand-Book for American Travellers in Europe*. New York: Clark, Austin & Smith, 1854.

Peale, Rembrandt. *Notes on Italy*. Philadelphia: Carey & Lea, 1831.

Pine-Coffin, R. S. *Bibliography of British and American Travel in Italy to 1860*. Florence: Biblioteca di Bibliografia Italiana, 1974.

Richardson, E. P., and Wittmann, Otto, Jr. *Travelers in Arcadia: American Artists in Italy, 1830–1875*. Exh. cat. Detroit: Detroit Institute of Arts, 1951.

Savinetti, Holly Pinto. *American Artists Abroad: The European Experience in the 19th Century*. Exh. cat. Roslyn, N.Y.: Nassau County Museum of Fine Art, 1985.

Scott, Leonora Cranch. *The Life and Letters of Christopher Pease Cranch*. Boston and New York: Houghton Mifflin, 1917.

Sheldon, George William. *American Painters*. Enlarged ed. New York: D. Appleton, 1881.

Silliman, Benjamin. *A Visit to Europe in 1851*. 2 vols. New York: G. P. Putnam, 1853.

Soria, Regina. *Dictionary of Nineteenth-Century American Artists in Italy, 1760–1914*. Rutherford, N.J.: Fairleigh Dickinson University Press, 1982.

Spassky, Natalie, et al. *American Paintings in the Metropolitan Museum of Art, Vol. 2: A Catalogue of Works by Artists Born between 1816 and 1845*. New York: The Metropolitan Museum of Art, 1985.

Story, William Wetmore. *Roba di Roma*. 2 vols. New York: Appleton, 1864.

Taylor, Bayard. *Views A-foot; or Europe Seen with Knapsack and Staff*. Rev. ed. Vol. 2 of *Prose Writings of Bayard Taylor*. New York: G. P. Putnam, 1862.

Tuckerman, Henry T. *Book of the Artists, American Artist Life*. New York: G. P. Putnam & Son, 1867. Reprint, New York: James F. Carr, 1966.

Tuckerman, Henry T. *The Italian Sketch Book*. Rev. ed. New York: J. C. Riker, 1848.

Vedder, Elihu. *The Digressions of V*. Boston and New York: Houghton Mifflin, 1910.

Walker, Corlette Rossiter, et al. *The Anglo-American Artist in Italy, 1750–1820*. Exh. cat. Santa Barbara: University Art Museum, 1982.

Watson, Wendy M. *Images of Italy: Photography in the Nineteenth Century*. Exh. cat. South Hadley, Mass.: Mount Holyoke College Art Museum, 1980.

Willis, Nathaniel Parker. *Pencillings by the Way*. London: Henry G. Bohn, 1845.

Wittmann, Otto, Jr. "Americans in Italy." *College Art Journal* 17 (Spring 1958): 284–293.

Wright, Nathalia. *American Novelists in Italy*. Philadelphia: University of Pennsylvania Press, 1965.

Wynne, George. *Early Americans in Rome*. Rome: Dapco, 1966.

WORKS ON SPECIFIC ARTISTS

GEORGE LORING BROWN

Leavitt, Thomas W., and Barry, William David. *George Loring Brown: Landscapes of Europe and America, 1834–1880*. Exh. cat. Burlington, Vt.: The Robert Hull Fleming Museum, 1973.

BENJAMIN CHAMPNEY

Champney, Benjamin. *Sixty Years' Memories of Art and Artists*. Woburn, Mass.: Wallace and Andrews, 1900.

Keyes, Donald, et al. *The White Mountains: Place and Perceptions*. Exh. cat. Durham: University of New Hampshire, University Art Galleries, 1980.

THOMAS COLE

Baigell, Matthew. *Thomas Cole*. New York: Watson-Guptill, 1981.

Merritt, Howard S. *Thomas Cole*. Exh. cat. Rochester, N.Y.: Memorial Art Gallery of the University of Rochester, 1969.

Noble, Louis Legrand. *The Course of Empire, Voyage of Life, and other Pictures of Thomas Cole, N.A.* New York: Cornish, Lamport, 1853. Reprinted as *The Life and Works of Thomas Cole*. Ed. by Elliot S. Vesell. Cambridge, Mass.: Harvard University Press, The Belknap Press, 1964.

JASPER FRANCIS CROPSEY

Talbot, William S. *Jasper F. Cropsey, 1823–1900*. Exh. cat. Washington, D.C.: National Collection of Fine Arts, 1970.

Talbot, William S. *Jasper F. Cropsey, 1823–1900*. New York: Garland, 1977.

ROBERT S. DUNCANSON

Hartigan, Lynda Roscoe. *Sharing Traditions: Five Black Artists in Nineteenth-Century America*. Exh. cat. Washington, D.C.: Smithsonian Institution, National Museum of American Art, 1985.

McElroy, Guy. *Robert S. Duncanson: A Centennial Exhibition*. Exh. cat. Cincinnati: Cincinnati Art Museum, 1972.

SANFORD ROBINSON GIFFORD

Cikovsky, Nicolai, Jr. *Sanford Robinson Gifford (1823–1880)*. Exh. cat. Austin: The University of Texas Art Gallery, 1970.

Weiss, Ila. *Sanford Robinson Gifford (1823–1880)*. New York: Garland, 1977.

GEORGE INNESS

Cikovsky, Nicolai, Jr. *George Inness*. New York: Praeger, 1971.

Cikovsky, Nicolai, Jr. *The Life and Work of George Inness*. New York: Garland, 1977.

Cikovsky, Nicolai, Jr., and Quick, Michael. *George Inness*. Exh. cat. Los Angeles: Los Angeles County Museum of Art, 1985.

JOHN FREDERICK KENSETT

Driscoll, John Paul, and Howat, John K. *John Frederick Kensett: An American Master*. Exh. cat. Worcester, Mass.: Worcester Art Museum, 1985.

Howat, John K. *John Frederick Kensett, 1816–1872*. Exh. cat. New York: American Federation of Arts, 1968.

SAMUEL FINLEY BREESE MORSE

Mabee, Carleton. *The American Leonardo: A Life of Samuel F. B. Morse*. New York: Alfred A. Knopf, 1943.

Morse, Edward Lind, ed. *Samuel F. B. Morse: His Letters and Journals*, 2 vols. Boston and New York: Houghton Mifflin, 1914.

Staiti, Paul J., and Reynolds, Gary A. *Samuel F. B. Morse*. Exh. cat. New York: New York University, Grey Art Gallery and Study Center, 1982.

WILLIAM LOUIS SONNTAG

Miles, William Sonntag. *William L. Sonntag, 1822–1899 / William L. Sonntag, Jr., 1869–1898*. Exh. cat. Boston: Vose Galleries, 1970.

Moure, Nancy Dustin Wall. *William Louis Sonntag: Artist of the Ideal, 1822–1900*. Los Angeles: 1980.

JOHN SARGEANT ROLLIN TILTON

Barry, William David, and Baxter, Jean M. "John Rollin Tilton." *Antiques* 122 (November 1982): 1068–1073.

THOMAS WORTHINGTON WHITTREDGE

Dwight, Edward H. *Worthington Whittredge (1820–1910): A Retrospective Exhibition of an American Artist*. Exh. cat. Utica, N.Y.: Munson-Williams-Proctor Institute, 1969.

Whittredge, Worthington. "The Autobiography of Worthington Whittredge." Ed. by John I. H. Baur. *Brooklyn Museum Journal* I (1942): 5–68. Reprint, New York: Arno Press, 1969.